HISTORIC CUMBRIA
OFF THE BEATEN TRACK

BETH & STEVE PIPE

AMBERLEY

First published 2015

Amberley Publishing
The Hill, Stroud
Gloucestershire, GL5 4EP

www.amberley-books.com

Copyright © Steven and Beth Pipe, 2015

The right of Steven and Beth Pipe to be identified as
the Author of this work has been asserted in accordance
with the Copyrights, Designs and Patents Act 1988.

ISBN 978 1 4456 4564 3 (print)
ISBN 978 1 4456 4572 8 (ebook)

British Library Cataloguing in Publication Data.
A catalogue record for this book is available from the
British Library.

Typesetting by Amberley Publishing.
Printed in the UK.

Contents

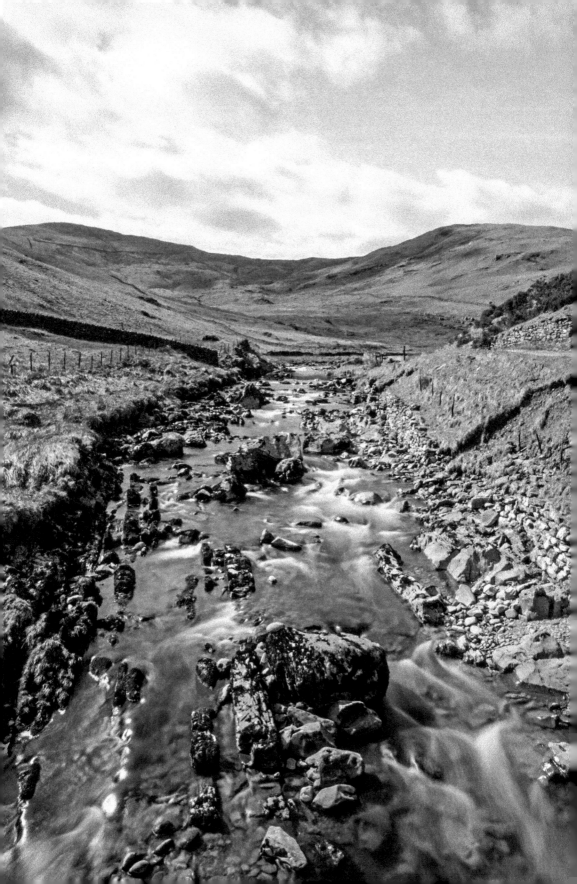

The author and publisher would like to thank the following people/ organisations for permission to use copyright material in this book: Mountain Heritage Trust and John Malden.

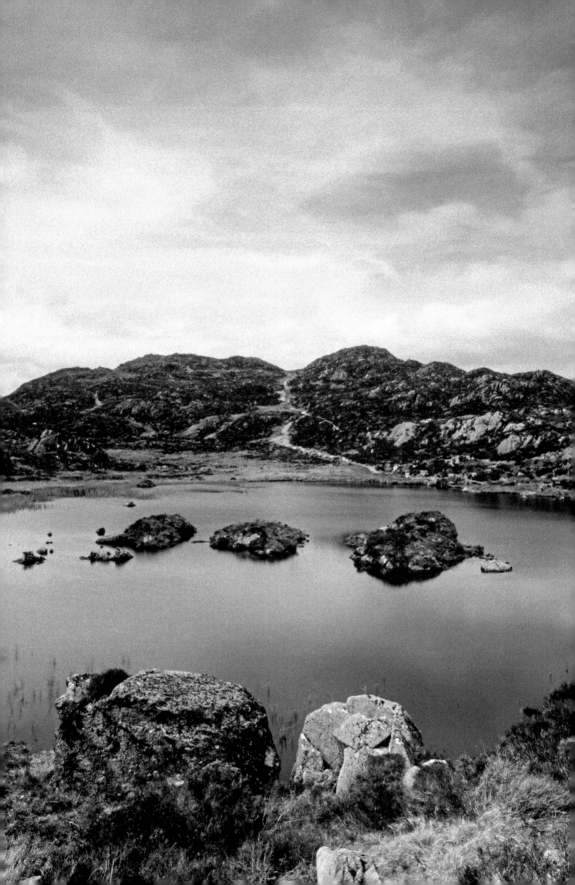

Introduction & Acknowledgements

This book came about because we are nosey hikers. It's never been enough for us to just hike a route; we always take time on our journey to look for clues and understand what happened in the past.

Over the years this has led to us uncovering some remarkable things about Cumbria. It's also led us to a greater appreciation of the people who came before us and lived in the days before electricity and motorised transport; people who had to get out and about whatever the weather, without the aid of waterproofs and 'proper' hiking boots.

We're also keen to use this opportunity to explore the whole of Cumbria, a county with a complex history, especially when it comes to the changing names of the administrative regions. These have gone through many incarnations, the most recent being the Cumberland, Westmorland, Lancashire boundaries which existed until 1974 and which many people still identify deeply with today.

There are many fascinating places to explore, places you may not immediately think of visiting but which offer superb views, fabulous walks and interesting insights into how the county came to be the way it is.

We've had an absolute ball pulling everything together but could not have done it without the magnificent help and support of a number of important people and organisations: thanks must got to Cumbria Wildlife Trust for their superb knowledge and infinite patience and to Cumbria Libraries who not only have an enormous range of important and interesting old documents, but were also brave enough to allow us to handle them.

Thanks to the RSPB for their help, particularly around Haweswater, Kendal Museum for allowing us access to some hidden away exhibits and Luneside Archaeological Society for their wealth of information about Low Borrowbridge. Additional thanks go to Morecambe Bay Partnership, Mountain Heritage Trust, the Beacon and Haig Pit Museums in Whitehaven, Bampton & District Local History Society and the Fish Inn, Buttermere.

High Street and Haweswater

If you're looking for a quiet corner within the national park, this is the place to be. Geographically it's further south than Ullswater but the only way to get to Haweswater by road these days is via the A6 and Shap; the ancient routes over the fell passes closed to motorised traffic some time ago.

Natural History

Haweswater is exactly the sort of glacial valley I used to look at in Geography text books as a kid, with tall steep sides and a broad flat valley floor. Before the reservoir was formed there were two smaller lakes here, Low and High Water, which were left behind when the glacier beat a retreat – they occupied the space towards the Bampton end of the valley.

The relationships of the rocks in the area can be best described in the same way as many other relationships – 'it's complicated' – with faults and ancient volcanic eruptions creating a mishmash of different rock types thrust up against each other. The least complicated fact is that pretty much all of them date back to the Ordovician period (461–451 million years ago) and most of them are volcanic.

If you're feeling adventurous and fancy exploring a bit more of the glacial landscape then take a walk up to Blea Water, it's a near perfect example of a glacial tarn.

What looks like an untouched landscape is actually very carefully managed and it's not always easy balancing the requirements of farmers with livestock with the desire to replenish the landscape and protect endangered habitats. United Utilities now own the land and work a number of farms in partnership with the RSPB. They have a jointly agreed management plan which aims to maintain the high quality of the water and protect, preserve and renew important habitats while allowing local farmers to graze their sheep on land they have used for hundreds of years.

No discussion of this area is complete without mention of the golden eagle once one of a pair but now alone since his mate died. This lonely male is the only golden eagle in England and can often be seen hunting to and fro along the valley and the reservoir. Eagles arrived in the area in the 1960s and sixteen chicks fledged from this site between 1970 and 1996. After that the remaining female became infertile before ceasing to lay altogether and sadly dying in late 2003.

The remaining male continues to build a nest each year but so far has not managed to tempt a mate down from Dumfries and Galloway – the next nearest breeding site. He spends most of his time blending in with the rocky moraine at the head of the valley and is very hard to spot, but it's worth hanging around for when he comes out hunting and displaying – something he still needs to do to ward off other would-be predators such as buzzards. He's currently around eighteen years old and could live on for another ten or more years enjoying his bachelor lifestyle. If you don't mind a bit of a hike you can get some spectacular views of both the eagle and the red deer down in Riggindale valley from Short Stile, a craggy outcrop up on the top of High Street.

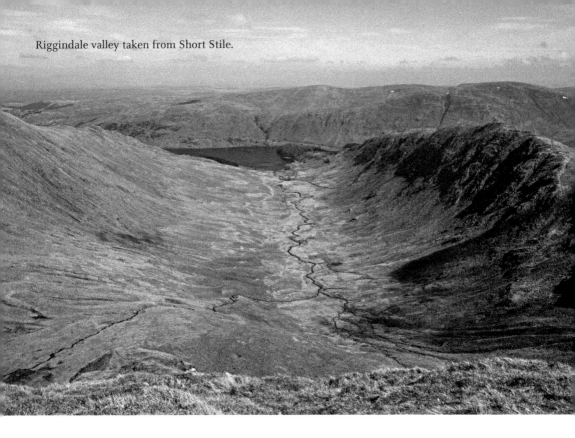

Riggindale valley taken from Short Stile.

Friendly locals above Haweswater.

Above: Golden eagle over
Riggindale.

Right: Red deer stag, Riggindale.

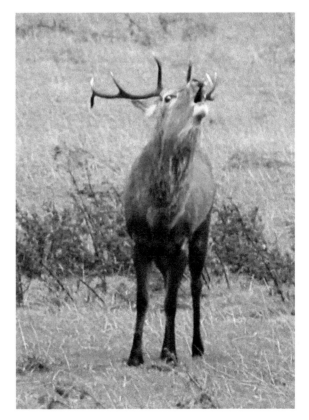

Early History

High Street is so called because it was once a busy thoroughfare created by the Romans to link Ambleside to the south (known as Galava) with Brougham to the north (known as Brocavum). While it may at first seem somewhat crazy to create a road 20 miles long across the top of a mountain, a quick look at the map shows that it was the most sensible way to link the two places.

Starting from Ambleside the route winds along the lower slopes of Wansfell before heading along Troutbeck valley and up onto High Street with only one steep, but fairly short, climb. Once on top of the fell the route is broad, mostly flat and very easy to follow (in good weather) and up until as recently as 150 years ago fairs and even horse races were held up there, which explains how Racecourse Hill got its name.

Evidence of people having lived in the area before the Romans exists in the shape of the fort at Castle Crag on the north-west side of the lake. The remains of an oval castle-like structure, thought to be an Iron Age fort, gave the crag its name, though it's unlikely it was an actual castle. Archaeological excavations over the years have identified artificially flattened floor areas within ramparts of stones and external ditches cut to give additional protection to those inside. Given its position and isolated location it's likely that it was built to offer protection from wolves or bands of thieves that roamed the area – even into the eighteenth century there were skirmishes along what is now the Scottish border and it would have been necessary for people to protect their family and livestock.

In 1366 the archers of Kendal, led by Captain Whelter (whose name lives on in the nearby Whelter Crags), laid a trap after they had warning of an impending raid. The archers lay in wait near Castle Crag and unleashed volleys of arrows onto the raiders as they appeared through the nearby passes, killing them all and then burying them where they fell. The Kendal archers were famed in their day and are credited with playing an instrumental role in the defeat of the French at Agincourt.

Mardale also had its very own kings, though how much of this story is fact and how much is fiction is difficult to tell. The story originates with Hugh Holme who fled north in 1209 after being implicated in a plot against King John. He supposedly took refuge in a cave high in Riggindale and although the death of the king meant it was safe for him to return home, he opted to stay, eventually moving down into the village. His line of descendents were known as the 'Kings of Mardale' due to their benevolent acts and the line only ended in 1885 with the death of Hugh Parker Holme who is buried in nearby Shap.

Recent History

Recent history is right under your feet at Haweswater; the area is criss-crossed with numerous communications paths and coffin routes. In the days before electronic communications if you wanted to trade goods or information with nearby villages, or bury your dead in the nearest churchyard, this was the only way to do it, whatever the weather.

There are two passes leading out from the southern end of Haweswater; Nan Bield Pass bears south-west and Gatesgarth Pass bears south east and both are very popular with hikers. The routes are also a reminder that Mardale Green (see later) was an important stopping off point on a popular through route rather than the village at the end of a dead end road it is often depicted as.

Midway along Gatesgarth Pass is Wrengill Quarry which once produced roofing slate. It was worked for the best part of two centuries before closing after the Second World War; the final workers in the quarry were Italian prisoners of war and once the war was over the quarry was sold and most of the machinery removed.

Perhaps the most interesting and important aspects of the local history concern two villages, one of which only existed because of the demise of the other: Mardale Green and Burnbanks.

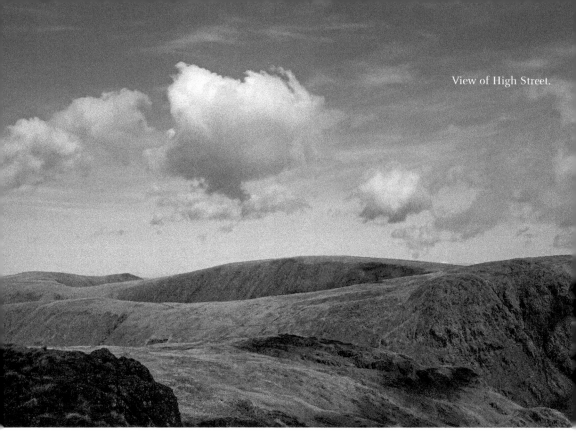

View of High Street.

Gatesgarth Pass.

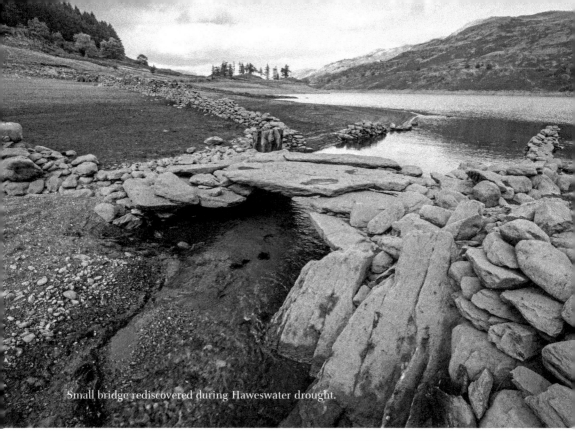

Small bridge rediscovered during Haweswater drought.

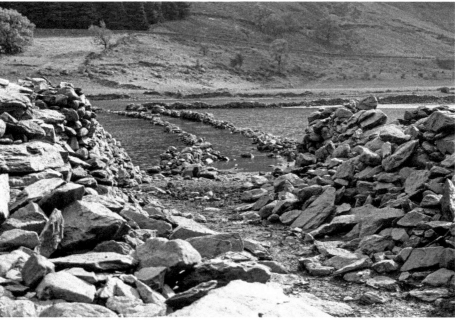

Mardale village emerges during droughts.

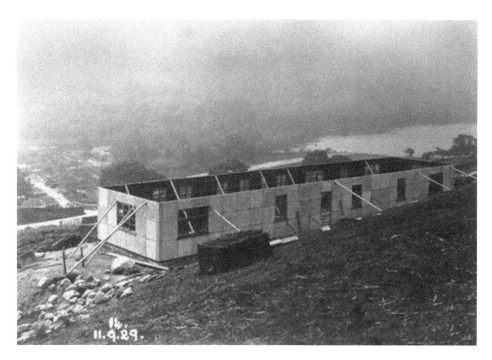

Burnbanks hostel under construction, provided for men without families. Image used with thanks to Bampton & District Local History Society.

View of Haweswater from Harter Fell.

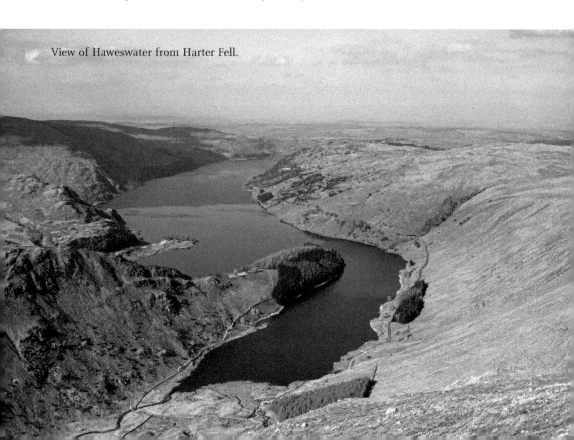

Mardale Green was by all accounts a beautiful settlement nestled peacefully at the head of Mardale Valley; these days it lies submerged beneath the waters of Haweswater reservoir, only peeking out occasionally during times of drought. In 1919 the Manchester Corporation obtained an Act of Parliament allowing them to build a dam across the head of the valley to raise the water levels, thus creating the reservoir but losing the village.

At that time Manchester was a city with poor living conditions and unquestionably needed a reliable supply of fresh water – many homes had no running water and toilets were outdoor earth closets shared with several other families.

Previously water had been supplied by the Peak District but drastic action was needed to meet the increase in demand from a growing population and industry. Strangely there was no impassioned protest against Manchester's plans and, unfortunately for the people of Mardale Green, the reservoir project went ahead, forcing them from the homes they'd lived in for generations. All of the homes in the village were destroyed prior to the flooding, as was the school, the Dun Bull Inn and the church, with all the graves being moved and the majority reinterred in Shap. Glass from the church windows was incorporated into the water intake seen along the eastern side of the lake.

As plans were made in the early 1930s for the community of Mardale Green to be moved away, the community of Burnbanks came into existence. Built as a temporary community, the homes were basic but offered electricity, running water and modern sanitation and were sturdy enough to withstand whatever the weather threw at them. The homes were ingeniously designed in cast-iron kit form and could be put together within a matter of days then dismantled and reused elsewhere when they were done with.

Around 400 workers, their wives and families were housed in sixty-six homes while the dam was constructed and, once all 470 metres of it were completed and the reservoir filled, the village could be taken apart. Some homes were left to house the essential maintenance workers and for temporary housing they did pretty well with a thriving small community continuing well into the 1970s. During the 1980s many homes fell empty due to deterioration. In the late 1980s the RSPB took over a number of the remaining dwellings for volunteers who were part of the Eagle Protection Scheme.

Eventually the village was redeveloped and rejuvenated to meet the need for affordable local housing and in 2006 the 'new' village was opened. These days it is a thriving community and a lovely place to visit on a lap of the reservoir.

The Other Borrowdale

There are several Borrowdales in Cumbria, hardly surprising as the word Borrowdale is derived from the Scandanavian word for 'valley of the fort' and the county is awash with the remains of Roman forts. This particular Borrowdale is tucked away just north of Kendal and is a beautiful valley running from the A6 at one end to the Lune Valley at the other

Natural History

In a region which has more than its fair share of broad glacial valleys this little gem of a valley is delightfully different, though its steep narrow shape was very nearly its downfall. In the 1960s and 1970s two proposals for turning it into a reservoir were put forward. Thankfully both plans were thrown out leaving things looking much the same as they have for centuries.

At the far end of the valley, clearly visible along the M6, a heart-shaped plantation of trees stands out on the hillside. Despite several romantic tales surrounding this woodland, ranging from memorials to fallen soldiers to the final meeting place of star-crossed lovers, the truth is that it's simply the natural lie of the land with the gill running through that gives the wood its distinctive appearance.

Beyond the Far end of the valley the underlying rocks in the valley are relatively soft siltstones dating back to the Silurian period (419–423 million years ago) and just to the north is the huge Shap Granite intrusion which had a dramatic effect on the region both naturally and economically. Granite was quarried here for use as a decorative building stone and can be found in many grand buildings including the bollards in front of St Paul's Cathedral. The distinctive granite, with large pink feldspar crystals, was first quarried commercially in 1864 and although the main quarry was closed for some time its commercial viability is now being reinvestigated and it should hopefully be back in production again soon.

In the 1980s investigations were carried out on the granite by the British Geological Survey to determine whether the heat still contained deep within it was enough to provide a source of geothermal energy. A number of 300-meter-deep boreholes were sunk to measure the heat flow in the rock, but it was ultimately determined not to be an economically viable idea.

Rough Fell sheep are the typical sheep of this region they were first identified as a distinct breed in the Sedburgh Agricultural Show in 1848 and their black faces, white muzzles and stoutly built frames can still be seen along the valley. They are hardy, fertile and long-lived and nearly all the total flocks lie within 30 miles of Kendal. They're described as having a 'proper jacket' and their long and luxurious fleece is solid enough to protect them throughout the Cumbrian winters, even when they're carrying lambs.

The rather coarse clothing that resulted from these proper jackets was known as Kendal Bumps and the *English Dialect Dictionary* from 1905 describes them as being '... made in

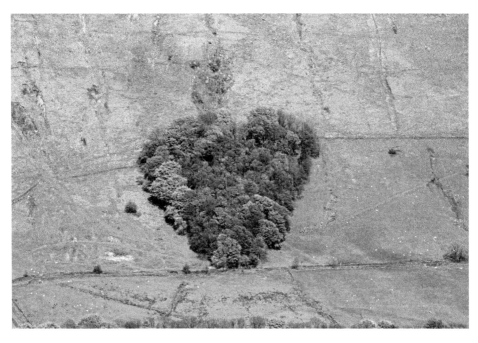

Heart-shaped woodland along Lune Valley.

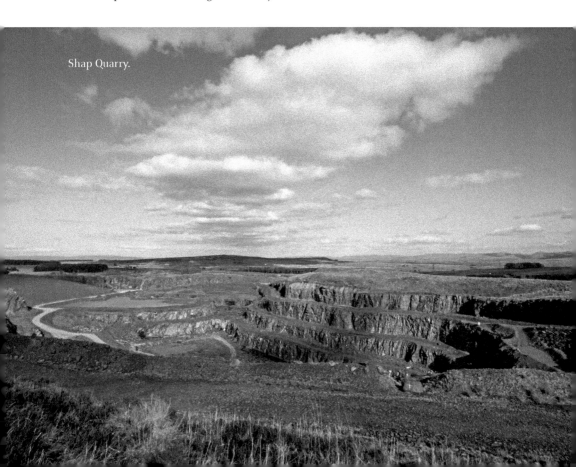

Shap Quarry.

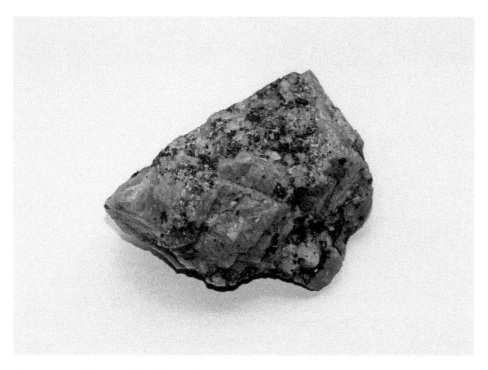

Shap granite, showing off Feldspar phenocrysts.

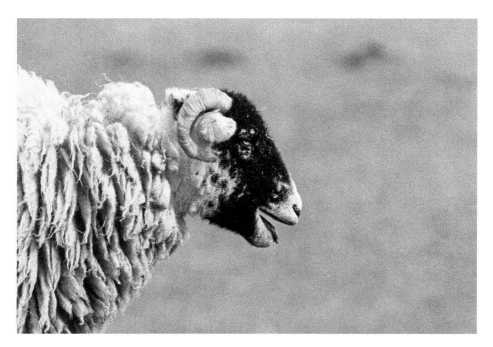

Rough Fell sheep and its 'proper jacket'.

large quantities during the last century for negroes of the West Indies and United States'. The term carried through to the twentieth century and was used locally as a term of mild derision for tourists in reference to their freshly purchased woollen clothing.

Sheep have had an enormous impact on the local landscape with their grazing patterns and the need to build dry stone walls to contain them; nearby Kendal's coat of arms originated in 1610 and depicts teasels and bale hooks used in the sheep trade with a motto which translates as 'Wool is my bread'. These days there are fewer sheep; wool that used to be enough to pay a year's rent is now worth almost nothing thanks to the introduction of manmade fibres and cheaper international imports. The sad reality is that for many famers the cost of shearing a sheep is now greater than the value of the wool produced.

Early History

On this eastern edge of the Lake District there is evidence of our ancestors dating back to the Romans and possibly earlier. The Lune Valley running along the eastern end of Borrowdale was a natural and relatively easily navigable thoroughfare which is still used extensively today. The M6, the A685 and the mainline railway all run alongside the Lune as does a much older Roman oad which would have linked the Roman fort at Low Borrowbridge with Kirkby Lonsdale away to the south.

The Roman fort is thought to have been built during the reign of Agricola in A D79 but, as is the case with many old forts, it was most likely built on the site of a previous structure. There have been many excavations of the fort and surrounding areas over the years and, by all accounts, it was an impressive building. An excavation in 1950 provided dating evidence to suggest the fort was occupied throughout the Roman period and may well have continued as a stronghold for local chieftains after the Romans had left.

The remains of a hypercaust were also found – an ingenious warm air heating system with a furnace at one end driving hot air along corridors of bricks beneath the floors and through the gaps in the walls of the dwellings. An excavation carried out in 1975 before the erection of a nearby barn uncovered the site of the furnace which would have provided all the heat.

In 1991/92 a natural gas pipeline was built which cut across the valley and during these excavations evidence was found of a cremation cemetery and the beginnings of the Roman road leading south from the fort and along the Lune Valley.

In August 1860 Cornelius Nicholson, one-time mayor of Kendal and prominent local historian, gave a lecture to Kendal Natural History and Scientific Society detailing the results of recent excavations. He noted the discovery of the hypercausts, assorted pieces of pottery and four hand grinding mills – two of which were given to Kendal museum. He estimated the fort to be 21,000 square feet (1,951 square meters) and was likely to have housed four cohorts of 480 men and their horses.

Today there is little to see of the fort apart from its outline, though this is very easy to pick out on Google Earth; however in both 1777 and 1840 local visitors reported seeing 'ruins of a castle-like structure' and the most likely scenario is that the stones from the fort were taken and used in the construction of other local buildings, which was common practice at that time.

Recent History

One of the key influencing factors on the evolution of Borrowdale was the development of local communication routes. The A6 which now connects Kendal to Shap was predated by another road, 'The North Road', which was first used in medieval times and can still be traced today. Much of the route is still accessible, though large sections of it are now bridleways and footpaths and no longer open to vehicles.

In 1675 the map maker John Ogilby only noted four roads of importance in Cumbria,

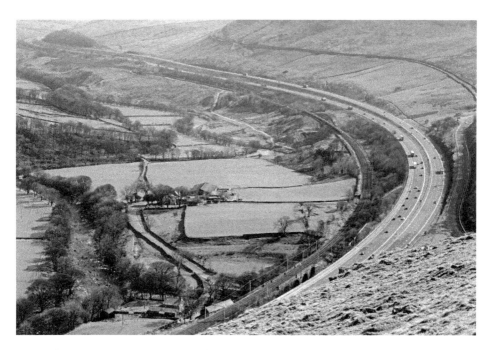

Lune Valley communication routes and site of Roman fort.

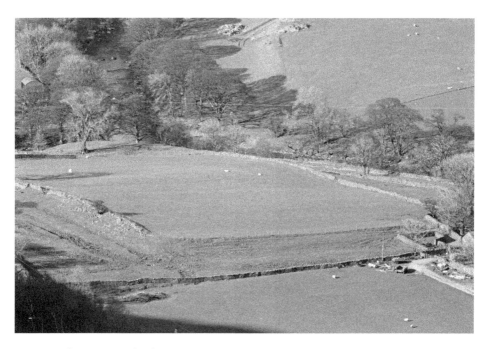

Remains of Low Borrowbridge Roman Fort.

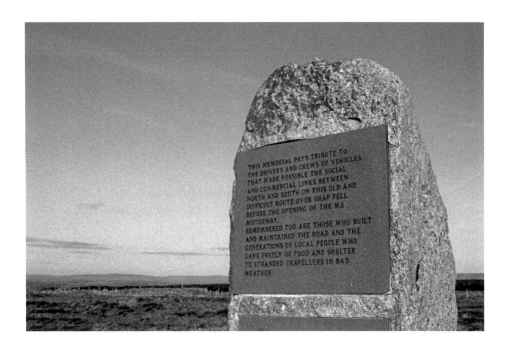

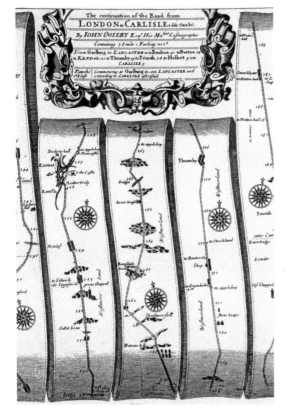

Above: Shap Fell memorial.

Left: Extract from Ogilby's map of 1675.

and the North Road was one of them. From Kendal the old road roughly follows the A6, diverging and re-crossing it at times, before rejoining it at the Shap Granite Works. It wasn't the most luxurious of roads and several accounts from the 1600s report that it was largely comprised of either bogs or rocks.

In the late 1700s, during the reign of King George III, turnpike trusts were set up to maintain and run roads in Britain. The trusts were granted powers by acts of parliament to acquire land and build roads; toll houses were built along the routes and charges imposed to improve the quality of the roads, although the tolls were about as popular back then as they are today.

And, if you think Bank Holiday traffic on the M6 is bad, spare a thought for the folks in the 1700s when the journey from London to the Lake District involved three days of travelling in uncomfortable, unheated carriages clattering over stone roads with only rudimentary suspension. They must really have wanted to get here.

At the western end of Borrowdale, just beyond the A6, is Huck's Bridge. This was the site of an old tollhouse and the bridge took its name from Gerrard Huck, the first tollkeeper in 1777. Prior to that it was generally not kept in the best condition and was described as being 'ruinous' in a report from 1712. On 14 December 1745, in response to the Jacobite uprising and invasion by the army of Bonnie Prince Charlie from Scotland, orders were given to demolish the bridge to make the road impassable for artillery and wheeled carriages.

On 16 December, just a few miles further south at Forrest Hall, the prince's troops got into trouble when were forced to stop due to the steepness of the hill. The soldiers were ordered to shift the heavy ammunition to the unbroken wagons but when a nearby pond was later drained, a large number of grenades were discovered, suggesting the soldiers

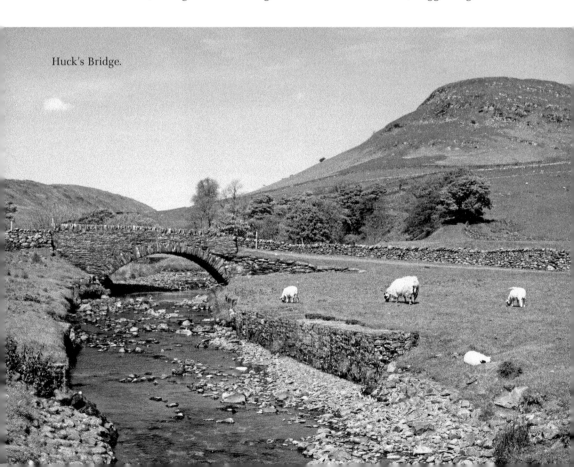

Huck's Bridge.

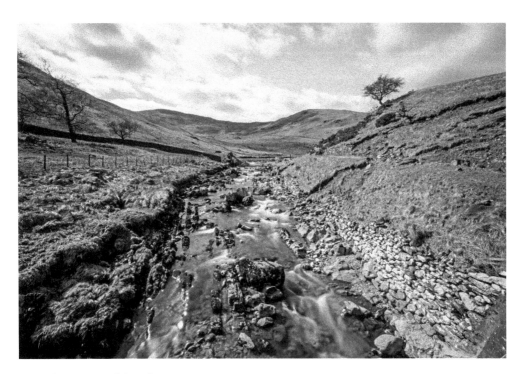

View along Borrowdale Valley.

preferred to offload some of the weight altogether rather than try to carry it on to Shap. Many of these grenades can be found in Levens Hall and one is on display in Kendal museum.

High Borrowdale Farm was first mentioned in 1180 in relation to the monks of Byland Abbey. In 1655 we find the first evidence of a member of the Holme family living at Borrowdale and the family remained associated with the farm right through to the twentieth century. Wills and documents of sale show the main assets through the years to be livestock in the form of sheep and cattle, suggesting the farms were very active.

Some firsthand accounts of life in the farms have been recorded from the 1930s and 40s – they paint a picture of a life which was tough by today's standards but clearly loved by those living it. Mrs Scott of High Borrowdale Farm and Margaret Hodgeson of Low Borrowdale Farm recall getting to school by walking along the valley to the A6 to catch the taxi. If the weather was bad one of their fathers might pick them up in the horse and cart with a tarpaulin thrown over to keep them dry – but if it rained too hard and the river flooded there was no school.

In 2002 the Friends of the Lake District bought the farms and surrounding land which it now leases for the grazing of Rough Fell sheep.

Smardale Gill

This valley gets its name from the old English word *smere* which means clover, so a literal translation of the Smardale would be Cloverdale, very fitting for such a lovely area. The saying 'When I was your age, all this was industry', always leaps to my mind when I visit as many of the features which make the valley what it is today are only there as a result of a rather industrial period in the recent past.

Natural History

The main rock is limestone, formed under warm shallow seas during the Carboniferous era 350 million years ago. The limestone is the reason the area was quarried, the kilns were built and the original reason the railway lines came here – but more of that later.

Further along the valley you'll also find some splendid red sandstone outcrops where they quarried the rocks to build the viaduct.

My background is in geology and, although there are many spectacular geological phenomena in the world, I have a real soft spot for limestone. Limestone pavements occur where the rock is weathered into an array of clints (blocks) and grykes (fissures) to form flat pavements full of rare and hidden-away ecosystems. The limestone also gives rise to calcareous soils, not the richest in nutrients, but the perfect habitat for limestone grasses such as the scarce Blue Moor-grass which in turn attracts the even rarer Scotch argus butterfly (this is one of only two sites in England where you'll find it). The butterflies lay their eggs on these low-level grasses so if you're up there during the summer months, be sure to stick to the footpaths.

There are only 1,000 hectares of mountain hay meadow in the world and while the disued railway line that runs from Newbiggin into the reserve is not a typical looking mountain hay meadow, it's full of typical hay meadow species such as wood cranesbill and melancholy thistle. In the summer it's a riot of colour and is managed naturally by being cut for hay and grazed by ponies.

Along the floor of the ancient woodlands lining the steep valley sides you should be able to spot the distinctive four-leafed shape of herb paris – an indicator species for ancient woodlands and, depending on the time of year, you'll also find wild garlic, bluebells or primroses. Most of the non-native tree species of larch, spruce and sycamore have been removed, leaving behind a beautiful woodland of ash, birch, hazel and willow.

Scandal Beck (from 'skaun' meaning 'fertile meadow') is home to the rare white-clawed crayfish. It's Britain's only native freshwater crayfish and it is under serious threat from the American signal crayfish which arrived in our rivers after escaping, or being deliberately released, from a private aquarium. Unfortunately the only time we spotted a white crayfish was when it was being eaten by a passing heron, who clearly hadn't read the memo. While you're down along the beck you should also be able to spot dippers skimming along the surface and diving down for their dinner.

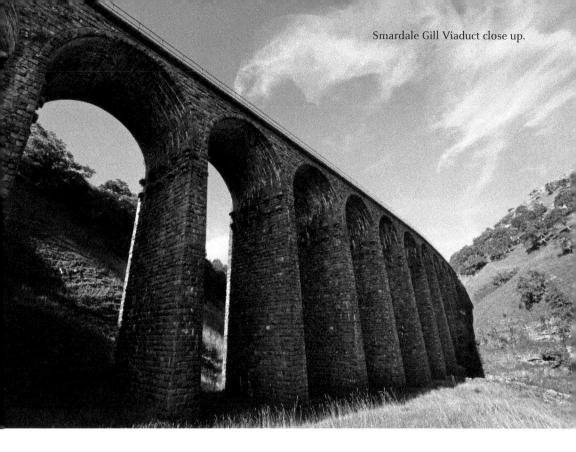

Smardale Gill Viaduct close up.

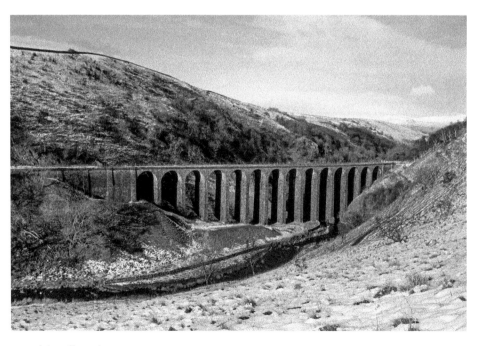

Smardale Gill Viaduct in winter.

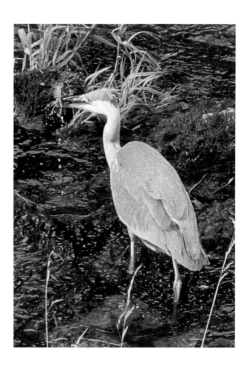

Heron eating a rare white-clawed crayfish.

Since 1978 the area has been owned and managed by Cumbria Wildlife Trust who use natural methods, such as controlled grazing, to manage the reserve as well as regular work parties of volunteers pitching in to clear scrub and maintain walkways.

Early History

A quick glance at an OS map will show you that this is a place where man has been making his mark for many thousands of years.

The areas marked as 'Pillow Mounds' are known locally as 'Giants' Graves'. Following an investigation by the Royal Commission on Historical Monuments, it is thought they may have been built as rabbit warrens – an idea supported by a number of 'rabbit holes' in the bottom of the dry stone walls.

Romano-British settlements in the area have been described extensively by English Heritage and are listed as Scheduled Ancient Monuments. Smardale Gill would have provided ideal conditions for early residents – water, a steep-sided valley to offer protection from the elements, plus woodland and limestone. The settlements identified are thought to be homesteads which typically contained up to six dwellings with designs which predate the Romans; surrounding these homesteads the fields were laid out for both arable and livestock farming. In the hillside rising directly to the west of Smardale Gill viaduct are the remains of prehistoric round cairns (a burial mound usually used to inter important members of the community).

The fantastic thing about Smardale Gill is that there is such a rich history of occupation and you don't need to be an archaeologist to find the evidence; in fact you don't even need to leave your armchair. Simply locate Smardale on Google Earth, zoom in on the hillsides either side of Smardale Gill Viaduct and the evidence of ancient settlements quickly becomes apparent. Many hundreds of years of ploughing has disturbed and demolished some of the ancient field lines and although much of the land is easily accessible, you can see so much more from the aerial photographs.

Moving forward in time, just to the north of the main Smardale viaduct you will find Chapel Well, which is an ancient holy well and once used to sit either next to, or inside, an old chapel. A holy well is a title given to a spring or small body of water which through tradition or folklore is thought to contain restorative properties and it would have been common to have an associated building. It is thought that the chapel associated with Chapel Well was dismantled during the reign of Queen Elizabeth I and the bells used in what is now St Andrew's church in Crosby Garrett.

Smardale Hall in the middle of the village is a Grade II listed turreted dwelling, now part of a working farm and not open to the public. The buildings we see today date from the fifteenth and sixteenth centuries and have been added to over the years, though there is evidence of structures on the site before this. It's possible that it originated as a fortified house and a plan from 1670 shows an old fourteenth-century tower which is no longer there. The Smerdale family are recorded as having bought the manor (as it was called) in 1290 and in 1849 the hall was listed as being used for a farm.

In a valley of bridges there's one that predates the others; the County Bridge can be found crossing the beck to the south of Smardale Gill viaduct. Before the stone bridge there was a wooden bridge which was documented in 1649 as being in a state of decay and requiring repair following damage caused during the Civil War. On 12 October 1663 Captain Robert Atkinson rode across the bridge on route from Mallerstang to Kaber Rigg in his failed attempt to lead a rebellion against the restoration of Charles II. Unfortunately the anticipated supporters did not materialise and Captain Atkinson was caught, jailed, escaped, re-caught and eventually hanged for his crimes on 24 August 1664.

He wasn't the only rebel in the area either; in 1665 Elizabeth Gaunt from Friars Bottom Farm just south of the bridge was wrongly implicated in the Rye House Plot to assassinate Charles II. She became the last woman in England to be intentionally burned alive (she was specifically denied strangulation, which normally preceded the sentence) but apparently went to her gruesome death with a '... cheerfulness which struck all who saw it.'

The bridge that remains is an eighteenth-century packhorse bridge; folklore has it that there was once a pub next to the bridge, but there's no substantive evidence of this and these days it's a picturesque spot from which to admire the valley or pause for a picnic.

Recent History

A lot of the recent history revolves around the viaducts which cross the valley so elegantly. The viaduct at the northern end of the valley is the Smardale Viaduct and still carries trains on the Settle to Carlisle route. Construction of the line began in 1869 and it took seven years to build, which seems like a long time until you consider that the track is 72 miles (116 km) long with fourteen tunnels and twenty viaducts, and not just any old viaducts, these are sweeping arched creations and the only downside of being on a train travelling across them is that you can't actually see them. The line opened to passengers on 1 May 1876 and still runs today, despite two attempts to close it down, one by Dr Beeching in the 1960s and a more recent attempt in the 1980s.

The Smardale Gill Viaduct crosses the valley further south; it is 90 feet (27.43m) high with fourteen arches and was designed by Thomas Bouch. The line opened in 1861 and connected Tebay to Darlington; in its early days it carried iron ore and coke from Durham to the furnaces at Barrow and didn't open to passengers until 1910. It is now no longer in use to carry a railway line, but it is still in use to carry hikers with a head for heights. On days when the wind whips between the arches and whistles through the handrails it sounds for all the world like the ghosts of long departed steam trains are coming back to haunt us.

Running through some of the most beautiful but remote countryside in Britain wasn't without its challenges though and snow during the winter could be particularly

The old County Bridge.

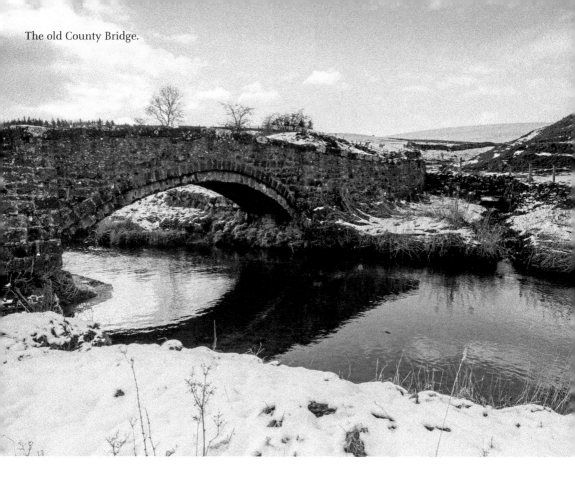

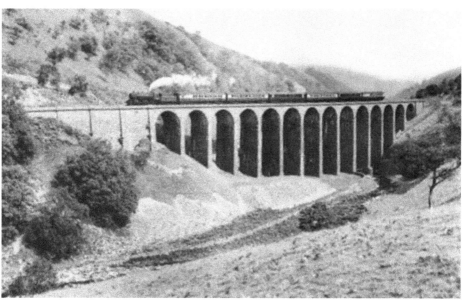

Steam train passing over Smardale Gill Viaduct.

Old railway cutting leading from Brownber.

Horse and cart crossing the line near Brownber.

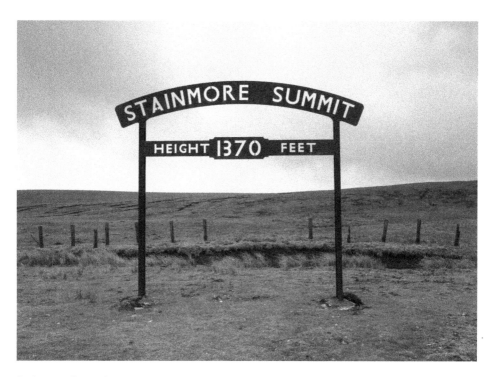

Stainmore Summit.

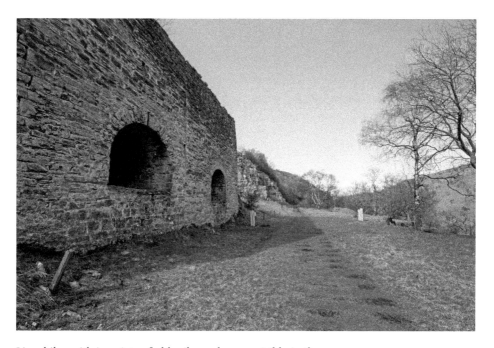

Lime kilns with imprints of old railway sleepers visible in the grass.

problematic. In 1947 a signalman at the Griseburn signal box just to the south got snowed in for three days and just to the north, at Bleath Gill near Stainmore Summit, a train got stranded in deep drifts in 1955 and it took five days to free it. (Take a look at the film *Snowdrift at Bleath Gill* on YouTube)

The two lime kilns were built in the mid-nineteenth century and were used to burn limestone and create quicklime which had many uses including fertiliser, creating a traditional lime whitewash for walls and being added to mortar, concrete and cement. A siding from the main railway line to the kilns shows how the quicklime would have been transported.

The cottages near to the limekilns are old railway workers' cottages and although now derelict and boarded up, access has been created for birds and bats. In her lovely book *Smardale Summers* Penny Whitehall recounts what it was like as a child growing up in one of the cottages. She spent her summers sliding down the nearby long barrow on a tin tray, learning to swim in the beck and exploring the surrounding countryside.

They usually arrived at the cottage by car and had to park two fields away, but on one occasion, just after the end of the Second World War, her father was arriving by train with a heavy suitcase. Rather than have to lug the case all the way back along the line from the station to the cottage, he simply opened the window of the carriage as they were passing the cottages and threw the case to his waiting family – much to the concern of the two elderly ladies sat opposite him who were convinced they were witnessing the actions of a covert spy!

Sadly the cottages now lie empty and the railway is no more, having been closed in 1962. The viaduct was in danger of being torn down at one stage but was rescued by the Northern Viaduct Trust, who bought it from the British Railways Board in the late 1980s and completed a full restoration in 1992 when it was reopened to the public.

Old railway cottages, now boarded up.

Grange-over-Sands and Cartmel

Often referred to as the 'Riviera of the North' this sheltered corner of coastline in south Cumbria is a popular retirement spot. Only for fit pensioners, mind, as it's far from flat. The local history is heavily influenced by Morecambe Bay which provided the local industry as well as a means of access before roads and railways took over.

Natural History

The most noticeable feature here is the 120 square miles of mudflats and sand otherwise known as Morecambe Bay. Unlike most large bays, which look much the same at high tide and low tide, Morecambe Bay never stays the same from one hour to the next. At high tide the entire bay fills with water and at low tide it drains completely, leaving behind a pattern of rivers criss-crossing the sands. When the spring tides hit there's even a bore which runs up the River Kent, one of five rivers which empty into the bay (the others being the Leven, Keer, Lune and Wyre).

The spectacular mudflats, channels and shallow pools provide the perfect habitat for a huge variety of birds. Most evenings a stroll along Grange prom will be accompanied by a soundtrack of curlew and oystercatcher and if you pause a while you'll spot Knot, Little egrets, dunlins, redshank, starlings and a variety of geese among many others. The area is particularly busy during the migration season as a stopping off point for a number of species; during the evenings or at first light squadrons of birds arrive, or depart, overhead.

The shifting channel of the River Kent, possibly influenced by the arrival of the railway and viaduct, has had a big impact on the coastline. Prior to the 1970s it flowed more towards the Grange-over-Sands side of the bay-creating a sandy beach washed by tides twice a day. An account from 1850 notes that, at high tide, houses close to the shore could look down from their windows directly into the water below. These days the channel has shifted closer to Arnside, causing large areas of salt marsh to open up next to Grange which the tide only covers once a month at most, leading to some locals renaming it 'Grange-over-Grass'.

On land you will find remnants of the huge ancient woodlands which once covered the area. Eggerslack woods, near to the railway station, gained their name from the old Norse word '*eiger*' which means 'bore' and 'slack', the highest point of the tide – before the railway was built this area formed part of Morecambe Bay and the houses along what is now Windermere Road testify to having Morecambe Bay silts in the garden just a few inches below the soil surface.

There is evidence of coppicing in these ancient woodlands: cutting down stems almost to the ground in order to make use of the wood. Typically this wood was used for canes, poles and charcoal. In Brown Robin Nature Reserve (now managed by Cumbria Wildlife Trust) charcoal making still takes place during the spring and summer months and the charcoal produced can be bought in the village.

Just off the coast near Grange is Holme Island with its causeway linking it to the mainland. Legend has it that the island was given as a gift to the man who killed the

Sweeping views from Grange prom to Arnside Knott.

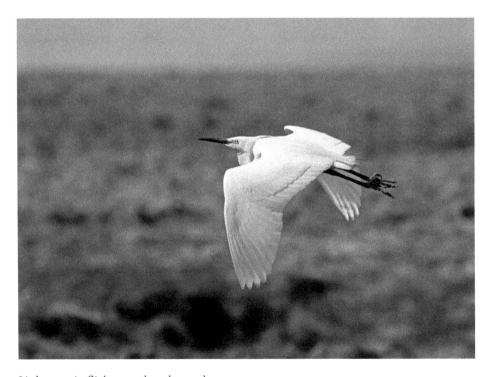

Little egret in flight over the salt marsh.

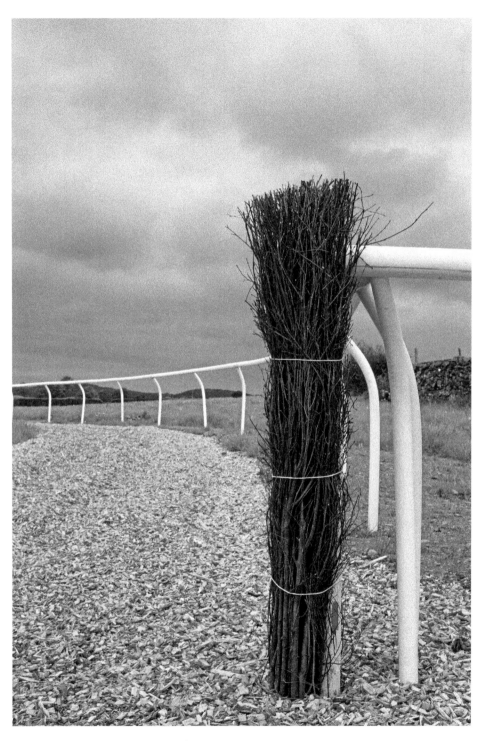

Coppice bundle in use near Cartmel.

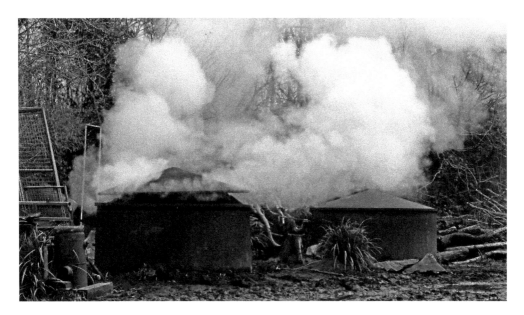

Charcoal burning.

last wolf in England on nearby Humphrey Head. On maps prior to 1857 Holme Island appears much further from the mainland; this is because when the railway was built an embankment was created which changed the shoreline. Just to the south of Holme Island you'll find two islands marked on the map: Great Crag and Little Crag, but there's a third island which rarely gets mentioned these days and that's because it rarely gets seen, which is precisely how it earned the name 'Seldom Seen' island as it appears only at very low tides.

Early History

The first mention of Grange in the history books comes in 1490, but in Cartmel we can go back earlier than that. In the *Annals of Cartmel* James Stockdale tells us that in AD 79 Agricola (the same Roman leader thought to have been responsible for building the fort near Borrowdale in chapter two) drove the Brigantes (powerful northern tribe of Celts who ruled northern Britain) north until they reached the southern shores of Morecambe Bay. They then passed over the low lying sand and Agricola led the Romans into Cartmel. Not everyone subscribes to this view but it makes for a great story.

The Celts, the Saxons and the Vikings all had different but very similar names for Cartmel: Caer-moel (Celts), Carth-mal (Saxons) and Garth-mell (Vikings) but they all translate to the same thing – an enclosed place (*caer*) among bare topped hills (*moel*), all of which possibly adds weight to the theory that the Romans had an enclosed camp here.

The name Morecambe Bay doesn't appear on a map until 1774 but it's likely the origin for the name comes from the astronomer Ptolemy who in AD 150 wrote that there was a place called 'Morikambe eischusis' (curved bay or salt flats) on the north-west coast of Britain. There was some disagreement at the time as to just where it related to, but in 1774 John Whitaker produced a map with the words Morecambe Bay on it and it's been there ever since.

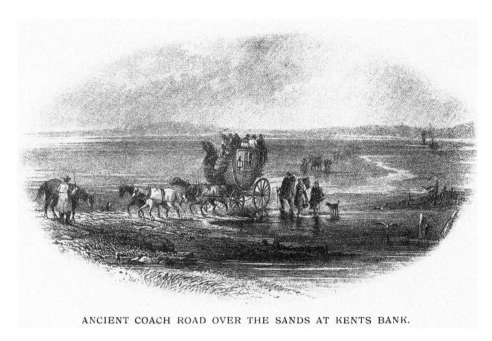

ANCIENT COACH ROAD OVER THE SANDS AT KENTS BANK.

Old coach road across the sands.

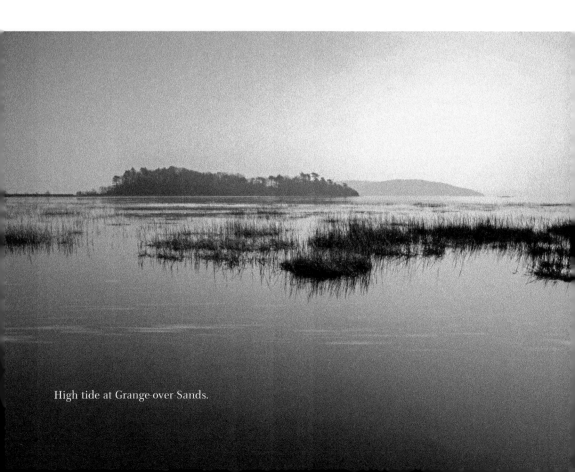

High tide at Grange-over-Sands.

And while we're on the subject of names, Grange comes from an old French word *grainge* (granary) as it was where the monks from Cartmel kept their grain. The original building is long gone but when the memorial gardens were being created a number of large stone slabs were found which may have originated in the granary. Years later a police station was built near the site of the old granary, which is now a hearing aid centre, though it apparently still has cells around the back. There's a date on the front of the building which reads '1684' but this was put there in the late 1960s by a builder with a misplaced sense of humour.

The 'over-Sands' part came thanks to Revd Wilson Rigg, who arrived in 1858 having nearly drowned on his way across the sands. He apparently got so fed up with his post ending up in Grange near Keswick that he added the 'over-Sands' bit to differentiate the two.

The priory in Cartmel was founded in 1188 by William Marshall on land given to him by Henry II; Marshall founded the priory in honour of Henry II and his son Henry the Younger. It was the only conventual monastery in Lancashire which escaped the Dissolution of the Monasteries during the Reformation and still dominates the centre of the village. There's a heavy wooden door in the southwest corner of the nave which is known as Cromwell's Door; if you examine it closely you'll see bullet holes in it reputedly made by Cromwell's men in 1643 when they stabled their horses there.

As you approach the town you may notice that many of the road signs welcome you to 'Grange-over-Sands Lancashire' and that's because, technically, it still is in Lancashire, but we have to go back a long way to prove it. In 1168 Lancashire was first referred to as a county by Henry II and it covered the area from the Mersey to Barrow-in-Furness. He gave the county to his second son Edmund who was made 1st Earl of Lancaster;the title passed to his son Henry who was made a Duke and the county was given Palatine status meaning it belonged to the palace.

This hereditary title has passed down through the royal family and today the Duke of Lancaster is the Queen. Despite administrative boundaries moving in 1974, the Palatine boundaries remain unchanged, meaning that Grange-over-Sands (and Barrow-in-Furness for that matter) are still in Lancashire and many locals still celebrate Lancashire Day on 27 November each year. It also means that when the Queen visits she is occasionally regaled with 'God Save the Duke' instead of 'God Save the Queen'. You may need that on *Who Wants to be a Millionaire* one day.

Recent History

In the 1851 census Grange had forty houses. It has a few more than that now and the population sits at around 4,000. This influx of people came from improvements in two main areas, the roads and the railways; prior to that the main access was across the treacherous sands of Morecambe Bay, which could be a bit of a hit and miss affair. Strangers arriving that way were called 'off-comers' as they had come off the sand and to this day it's still a term used locally to describe those who have moved into the area. As people arrived off the sands their first port of call was the Bay Horse (now the Commodore Hotel), which was built in 1730. Public coaches began to cross the sands three times a week in 1781 and in 1875 steamers began operating across the bay but these stopped when the channels shifted.

When the brave folks of the eighteenth century began to build roads across the area now used by the A590 they found the boggy land something of a challenge, reporting that 'an enormous quantity of earth was swallowed up in the bog soil before the foundations were sufficient'. Excavations for the building of the new dual carriageway unearthed old willow bundles laid down as part of the original foundations of the road, which explains why early road users noticed an 'undulating and quivering motion' when heavy vehicles passed along.

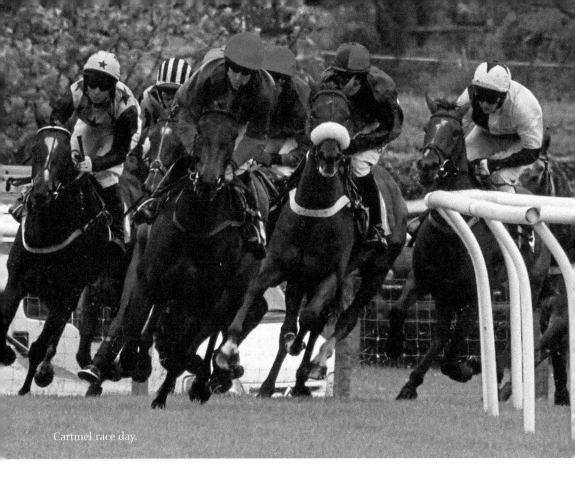

Cartmel race day.

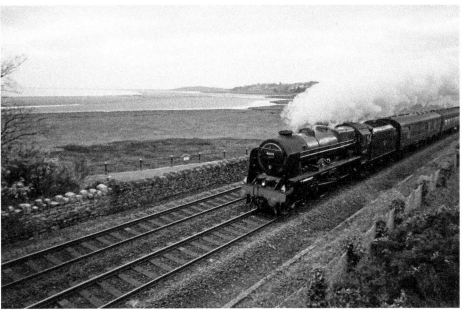

Steam train passing through Grange-over-Sands.

Ornamental Gardens, Grange-over-Sands.

Hampsfell Hospice.

Gradually the roads evolved but were still mainly used for horse-drawn vehicles until the early 1900s when Cartmel records having 779 stabled horses. By 1907 motorised transport was beginning to take over and a letter sent to the *Lakes Chronicle* complained about the '... beautiful roads being ruined by the sucking action of motorists' rubber tyres.'

On the subject of horses, the first race at Cartmel racecourse took place in 1856 and race events continue to this day. The circuit is just over a mile long and has the longest run in in the country (the distance from final fence to finish line). The railway probably helped the racetrack to survive where others failed and every year there are eight fixtures which turn the tiny village into hive of activity.

In the late 1800s the area was still very remote and isolated and those who we would now describe as being vulnerable – the elderly and housebound – struggled to get the food and provisions they needed; luckily there was a local character named Peggy Keith on hand to help. Peggy was a short stout lady who smoked a pipe, wore a man's coat and was a force to be reckoned with. Twice a week, whatever the weather, she took her horse and cart into Kendal or Cartmel to collect grocery orders for deliveries in Grange and Lindale. Local legend says she never forgot an order and was much missed when she was killed in a fall from her cart late one night.

In 1857 the Furness Railway arrived, changing Grange and the surrounding coastline forever. It made the town much more easily accessible for tourists and hotels and other related industries soon sprang up. In 1866 the Grange Hotel was opened by the Furness Railway, and the building between the hotel and the station (now a vet's) was refreshment room and the starting point for charabanc tours of the Lake District.

Immediately next to the station are the beautiful Ornamental Gardens which began life as a swamp. Following the arrival of the railway the area was reclaimed and landscaped with Picklefoot spring feeding the pond at a rate of 60 gallons per minute. Prior to 1879 and the creation of the reservoirs at High Newton, the whole of Grange had been supplied by freshwater springs such as this. Records show that Picklefoot spring has never run dry and during the long hot summer of 1976, when water levels fell across the country, it never faltered and was used by locals to top up their supplies.

Surprisingly, for such a remote place, Grange was a hive of activity during the Second World War with the Grand Hotel being commandeered and used as an RAF training base, complete with anti-aircraft guns on the roof. There was even a bombing raid on the town in May 1941, in which Yewbarrow Lodge was destroyed. The house belonged to Colonel Porritt, who had been sheltering evacuees from Manchester at the time; the poor things had left the city to be sheltered somewhere safer. Thankfully they all escaped unharmed.

Dunmail Raise and Thirlmere

One of the biggest challenges when writing about the history of Cumbria is separating folklore from fact, and nowhere is this more tricky than right in the heart of the Lake District where the facts have become so enmeshed with stories retold and handed down across the generations that's hard to know where one stops and the other begins. The problem with the folk stories is they are often more entertaining than facts, especially when ancient kings, bloody battles and lost treasures are involved.

Natural History

We're firmly back in the land of complicated rock formations here with faults and intrusions aplenty. The A591 from Grasmere to the middle of Thirlmere follows one long fault line, part of the Coniston Fault Zone and active 350 million years ago. The rocks in the landscape are predominantly igneous, resulting from explosive volcanic events, though there are a few bits of sandstone on the flanks of Helvellyn and Wythburn Fell.

The steep rugged sides are telltale signs of another glacial valley and the original lake (or lakes) beneath what is now the reservoir would have been left behind when the ice sheets retreated. These lakes were sometimes referred to separately as Leathes Water and Wythbun Water but were also referred to as Thirlmere, the name coming from the old English words for 'Gap' (*thyrel*) and 'Lake' (*mere*), giving us 'lake with a gap'. The two bodies of water looked rather like an elongated egg timer with the pinch point near Armboth.

We have the climate in Cumbria to thank for the beautiful green hillsides and shimmering blue lakes, but sometimes we get more than we bargained for. The 'great storm of 1749' swept along what is now Thirlmere valley, forcing people to flee from homes that were first crushed by falling rocks then swept away in the resulting flood. The terrified locals sought refuge in the trees as the 'torrents poured down for eight hours'.

Old photos of the area show a landscape with far fewer trees than we see today and an account from a cyclist in 1927 mentions a group of trees not far from Dunmail Raise, describing them as being 'the only shadowy spot within miles'. At that point Manchester Corporation (which owned the area) was in the process of planting over 1,900 acres of conifers to generate income and reduce soil erosion and up until the late 1990s the Christmas tree in Albert Square in Manchester came from Thirlmere. There is currently a replanting scheme underway which is replacing many of those conifers with indigenous broad leafed varieties, so in another hundred years it will all look different again.

The ancient volcanic activity resulted in rich seams of minerals such as iron, lead and copper and also several slate quarries. These mines have been diligently explored and mapped by the nearby Threlkeld Mining Museum and although many are marked on the OS map it is not advisable to try exploring them unless you happen to be very experienced in these things.

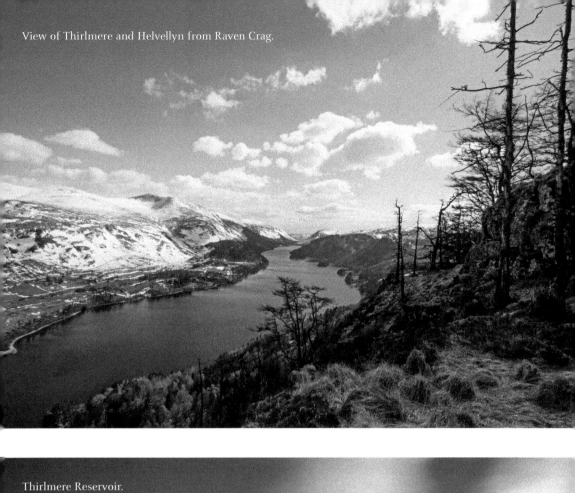

View of Thirlmere and Helvellyn from Raven Crag.

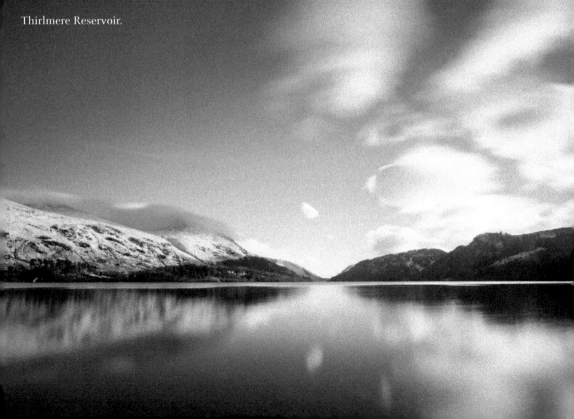

Thirlmere Reservoir.

Forestry Commission logging.

So far as the wildlife goes, the forests surrounding Thirlmere are a great place to spot red squirrels. We once had a fantastic up-close experience with one who posed beautifully for us until we reached for our cameras. We've also been startled by red deer racing through the woods, particularly above Launchy Gill. A hunting record from 1850 records a pine marten being accidentally killed in the woodland; these days they are long gone though there's a possibility of them making a comeback thanks to careful land management.

Early History

The nearby Castlerigg Stone Circle is evidence that man found his way into this beautiful landscape in Neolithic times. Back then the area would have been incredibly isolated and easier to go around than to go through. That isolation and lack of 'through traffic' is probably one of the things that attracted the early settlers, along with the plentiful water supply and abundant wildlife.

Two bronze amulets found near the base of Rough Crag provide us with evidence of people living in the valley in the early Iron Age. These amulets, now in Keswick Museum, were discovered in 1902 by workmen repairing the road alongside the lake and, from their account, were just lying in the top layers of rubble with no clear indication of how they got there.

Next up are the Romans and the possibility of a Roman road running parallel to the existing A591 has been explored and debated. In the fields to the north of Dunmail Raise there's clear evidence of a road running along the valley; the debate is over who put it there. Archaeologists have identified that it is well engineered and the style and quality indicate Roman origins, but as yet there is no definite proof.

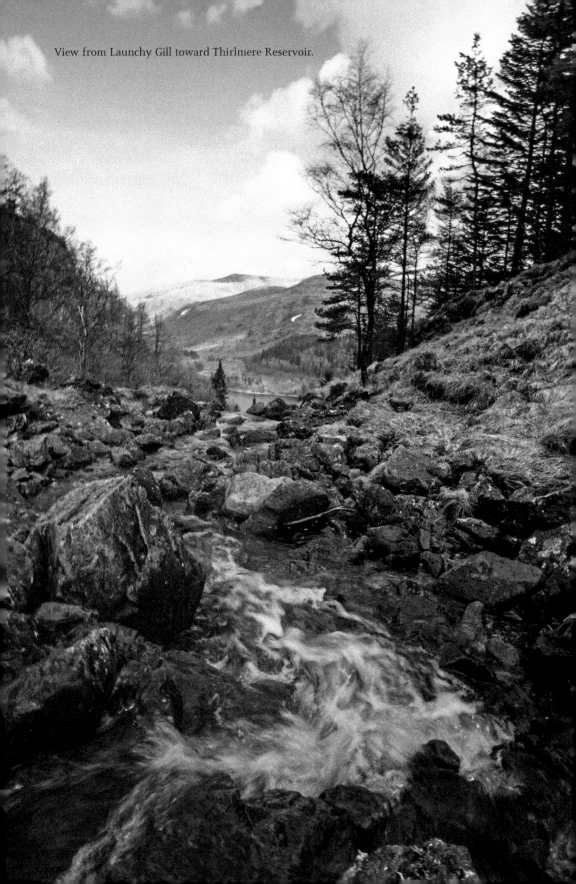

View from Launchy Gill toward Thirlmere Reservoir.

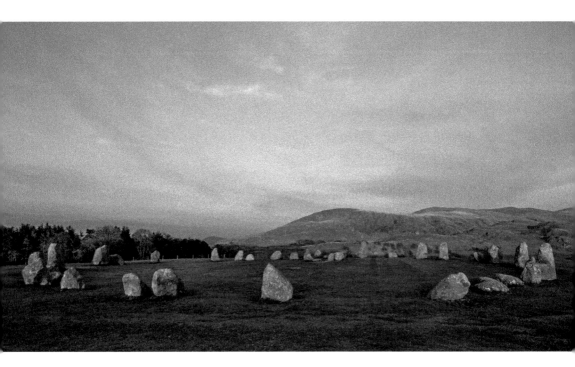

Castlerigg Stone Circle.

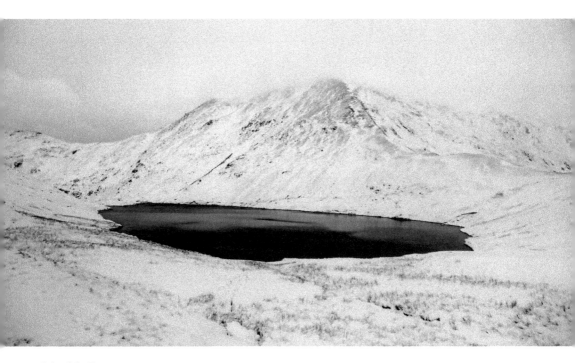

Grisedale Tarn.

Then we come to the most famous and complicated part of the history of this area: Dunmail. The folklore goes like this: King Dunmail (King of Cumberland) upset Edmund, King of England, and Malcolm, King of Scotland. They joined forces to fight Dunmail on the spot we now know as Dunmail Raise. During this battle King Dunmail was killed and his men ordered to pile stones on his body before hurling his crown into nearby Grisedale Tarn, although some versions have him hurling his crown in there himself before he died. Legend also has it that Edmund ordered that the eyes of both Dunmail's sons were 'put out' before he laid waste to Cumberland and handed it over to Malcolm.

The reality is still interesting, though a little less bloody. There *was* a King Dunmail who was the last of the powerful line of kings who had ruled Cumberland since the fifth century and he did upset Edmund, King of England, by forming alliances with his enemies. Edmund marched north and defeated him in battle at a spot which is unknown but is unlikely to be Dunmail Raise on account of the fact that no war graves have ever been found in the area. It's also unclear whether King Dunmail survived the battle as some accounts suggest he died, whereas others report him as dying in Rome many years later. Rather than being his grave it's thought that the large pile of stones at the top of Dunmail Raise were put there to mark the boundary between Cumberland and Westmorland.

They're also not the only interesting rocks in the valley; tucked away up above Launchy Gill is Web Rock which was an important trade spot during the plague of 1665. At that time many of the local markets were ordered to stop due to the dangers of spreading the disease but the locals still needed to trade their wool and webs (woven fabric). Far from the eyes of the powers that be, they met up at this desolate rock to trade their wares, exchange the latest news and make some much needed money to support their families. It's a tricky spot to find and is boggy in all but the longest and driest of summers, which demonstrates the lengths they were prepared to go to and how important this was to them.

Recent History

The recent history of this area is dominated by roads, aqueducts, reservoirs and the occasional poet. In 1762 the turnpike trust for the 'widening, repair and amending of the road' in this area was created. The trustees had the right to appropriate land to create the road; they did not have the right to 'pull down houses or outhouses, or run through paddocks, orchards or nurseries', which goes some way to explaining the curious twists and turns along the roads of today which follow the old turnpike routes.

In 1805 the artist Charles Gough fell to his death from nearby Helvellyn; his body was not found until three months later with his little dog still guarding him. It was a huge story of the time and William Wordsworth wrote a famous poem about it ('Fidelity'). In 1890 a stone was erected to commemorate the event which can still be seen near Striding Edge. Wordsworth also penned another poem about this valley; 'The Waggoner' charts the journey of Benjamin as he makes his way over Dunmail Raise and gives an interesting insight into life in the valley during the early 1800s.

While you're up on Helvellyn, keep an eye out for another monument, this one commemorating the first aeroplane to land on a mountain in Great Britain. On 22 December 1926 a small plane (Avro 585 Gosport) piloted by John Leeming and Bert Hinkler, managed to land safely before taking off and diving down the side of the mountain; luckily it regained enough height and narrowly missed Striding Edge.

The most important aspect of recent history was the creation of the reservoir which was met with ferocious opposition. In 1877 the Thirlmere Defence League was formed to fight Manchester Corporation's plans to dam the valley, flood the village of Wythburn (often referred to as the 'City of Wythburn' even though it was never more than a few houses) and create a reservoir for the people of Manchester.

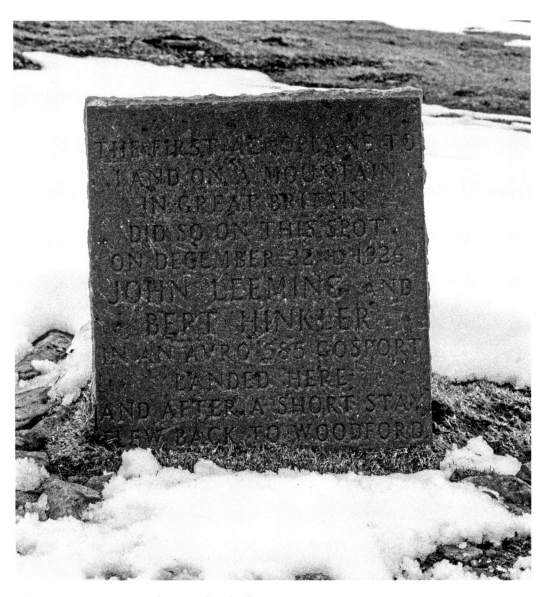

Monument commemorating first aeroplane landing on a mountain.

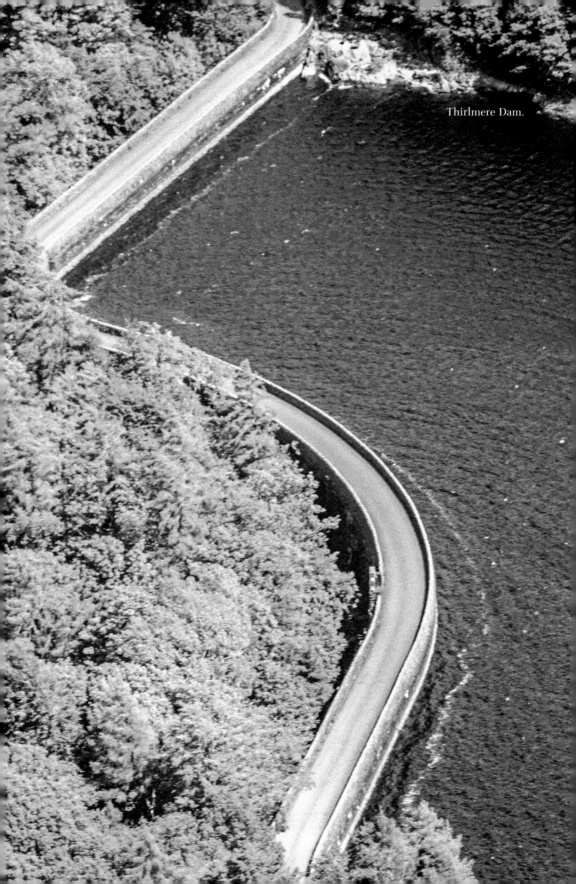

Thirlmere Dam.

The chief objection from the local residents, despite the obvious one of losing their homes, was the destruction of the beauty of the valley, which had been popularised by Lakeland Poets such as Wordsworth and Samuel Taylor Coleridge. There were also concerns that it would open the floodgates to other similar schemes. Given that Haweswater followed hot on the heels of Thirlmere they maybe had a point.

Despite the opposition Manchester Corporation eventually won out though they employed some interesting tactics along the way. They sent three representatives to the area posing as a cattle dealer, a builder and a tourist writer to try and buy up land before word of their plans got out and prices rose, but the locals were way ahead of them and they were often chased off land by angry farmers. Some locals held off selling, but once two of the biggest landowners reached a deal the others eventually followed.

The opposition was so fierce that in 1878 a special set of hearings were held during which time Manchester Corporation made a series of presentations in Windermere, Ambleside and Grasmere to win over the 'industrial people' with promises of work and to demonstrate that the opposition was only from the 'intellectual gentry'. Their ploy worked; work on the dam began in March 1890 and was completed in June 1894, two years behind schedule due to the problems with the bedrock.

Thirty-two large huts were built to house the workmen and their families and, though the flooding of the valley remained unpopular (rumour has it that Wainwright used to pee into the local streams as a mark of protest), Manchester Corporation gained a reputation as a good employer who looked after their workers well.

The reservoir holds 8,900 million gallons of water which is carried by the Thirlmere Aqueduct, a superb feat of Victorian engineering, 95 miles and 1,642 yards (154 km) to Manchester using only the power of gravity. The water flows at 2 mph, takes two days to reach the city and in 1897 a fountain was unveiled in Albert Square in Manchester to commemorate the opening of the aqueduct. The fountain was restored in 1997 and is still going strong.

Early photos and engravings show a very pretty set of three bridges known as the 'Celtic Bridges' crossing the narrow point near Armboth, which were lost beneath the flood. Among the important items which were rescued as the water levels rose was the 'rock of names' where the Lakeland poets had carved their initials during a summer picnic. The plan was to remove this in one piece, but sadly it broke up. All the bits were collected by Canon Rawnsley (local clergyman and founder of the National Trust) and rebuilt alongside what is now the A591. In 1984 this was replaced with a brass plaque and the original stone moved to Dove Cottage in nearby Grasmere.

The road alongside the east of the reservoir was one of the last coach routes south of the border and a coach and horses still travelled twice daily along the route well into the 1920s. The railways had been successfully prevented from penetrating deep into the lakes (thanks to opposition from the likes of Wordsworth) so, with no rail link north from Windermere to Keswick, horses were the only way to go.

And lastly, in an area that seems to have seen its fair share of battles there is one more piece of history to explain – you might spot a number of pill boxes on the nearby hills; these are a throwback to the Second World War when the Keswick Home Guard mounted a 24-hour watch on the lake amid fears the Germans could launch an invasion using flying boats. For such a peaceful spot, it's had a pretty turbulent past.

The old Celtic Bridges.

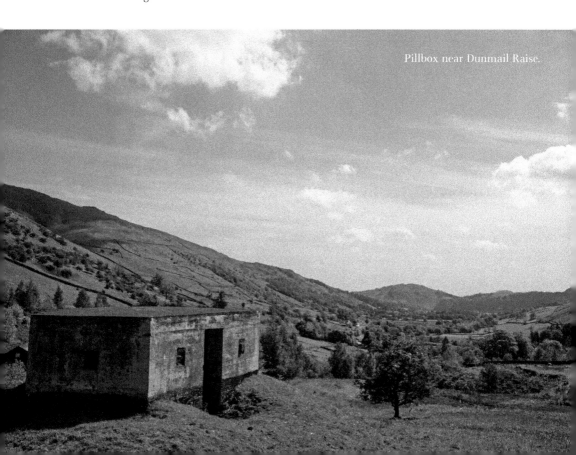

Pillbox near Dunmail Raise.

Kentmere and Longsleddale

These adjacent valleys just to the north of Kendal offer a language course in ancient Norse with their variety of place names. Both of them lie along ancient transportation routes connecting remote valleys within the Lakeland fells (the word 'fell' comes from the Old Norse *fjall* meaning 'mountain') and both have a rich history stretching from the Stone Age to modern day children's television.

Natural History

The oldest rocks here are the ancient sediments laid down 455 million years ago and known as the Skiddaw Group. On top of these is an unconformity, which means there is a gap in age between the rocks on the bottom and the ones immediately above. In this case the ones on the top are the Borrowdale Volcanic series from 10 million years later and which dominate most of the central fells. The Skiddaw Group were laid down when this part of the country was languishing somewhere around the equator and the fine sediments deposited as shales and mudstones were turned into slate as they were heated and deformed by the volcanic activity; it's those slates which explain many of the quarries along the Kentmere valley.

Once the rocks were in place it was time for the glaciers to do their work, leaving behind evidence which is familiar across much of Cumbria. The glaciers also left behind Kentmere Tarn, at first glance a fine example of a ribbon lake, but actually a lot more besides.

Sometime during the 1840s (nobody can pin down exactly when) the lake was drained to create additional farming land. This didn't quite work out as planned because the land it left exposed was too swampy and acidic to be of much use to the farmers, but what it did expose was a rich source of diatomite. Diatomite is formed in crystal-clear glacial lakes when the bodies of millions of diatoms (single-celled algae made of silica) die and fall to the lake bed. A detailed study of the area identified ninety different species of diatom laid down during four or five different phases, indicating the glaciers advanced and retreated several times.

The diatomite was extracted during the first half of the twentieth century for use in the asbestos industry with later extraction methods radically altering the shape of the north end of the tarn, creating the large bulbous spur on the north-east edge. These days Kentmere Tarn is full of water again and stocked as a fishery.

At the entrance to Kentmere Valley is Dorothy Farrer's Spring Wood, currently managed by Cumbria Wildlife Trust but in the past it was an important part of the local woodland industry. There is evidence of coppicing for bobbins, swill baskets (woven baskets made from thin strips of boiled oak) were made here and five charcoal burning sites can be easily identified on the reserve. The very best time to visit is in the spring when the entire woodland floor comes alive with wild garlic and bluebells.

Kentmere and Longsleddale (meaning 'long smooth valley') are among the most unspoilt valleys in Cumbria and are an absolute haven for wildlife with red deer, foxes and badgers

View at the head of Longsleddale valley.

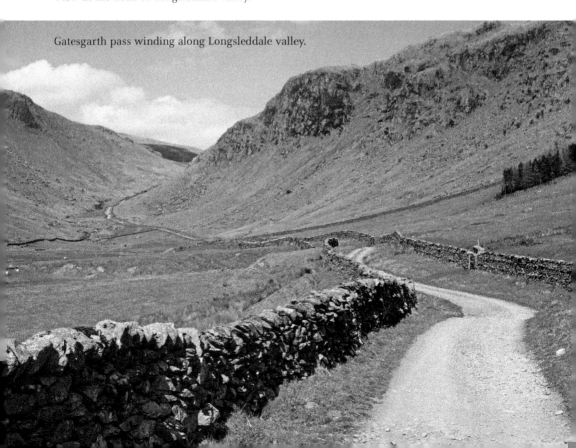

Gatesgarth pass winding along Longsleddale valley.

Bluebells and wild garlic in Dorothy Farrer's Spring Wood.

aplenty. The heather covering the hillsides along the two valleys provides perfect cover for ground nesting birds such as red grouse and merlin, so watch where you're treading if you're there during nesting season, and on most strolls you should be able to hear the cry of the buzzards and spot them as they circle over-head.

Early History
Although it's probable that man has been exploring, hunting and settling in these valleys for many thousands of years, the lack of detailed excavations mean that hard evidence is scarce. That said, Roman and medieval settlements have been found and a glance at an OS map shows many early settlements in both valleys. In most cases these old settlements lay along the old communications routes, routes that can still be walked today either by taking Nan Bield Pass up and out of Kentmere, or Gatesgarth pass from Longsleddale.

Kentmere Tarn and the surrounding area have had a particularly interesting history. In nearby Millriggs a glass bracelet dating back to AD 150 was found and in 1901 the Society of Antiquaries of London describes finding a number of building remains under the area that was once occupied by the lake (the lake being drained at this time). Although Roman in style, these buildings were thought to have been built after the Romans had left and could possibly have been the homes of Old Norse settlers.

The remains of old, possibly Roman, settlements can be seen along the valley at places such as Tongue House, which is clearly marked on the map and just about visible when you're there. There's also evidence of an Iron Age fort at Rook Howe in Kentmere, reinforcing the importance of these routes for trading.

One of the more remarkable finds was that of two dugout boats buried deep in the silts of the drained Kentmere Tarn. The first was found in 1955 and has been carbon dated

to the fourteenth century. The second was discovered deeper in the silts in 1959 and was more simplistic in design, suggesting it is somewhat older. This second boat can be found on display in Kendal Museum.

During the thirteenth century the area around Kentmere was divided into four manorial areas: Wray, Hallow Bank, Crag and Green Quarters. Back in the day, the Lord of the Manor had the right to raise fighting troops from those areas, a reminder that the valleys haven't always been as peaceful as they are today.

The solid pele tower at Kentmere Hall was built in the fourteenth century as was Yewbarrow (historically known as Ubarrow) Hall in Longsleddale and this is where the lords of the manor would have resided. The impressive structures were built at a time when stone buildings weren't common and although they both contain features which could be perceived as being defensive, it is more likely, given their positions, that they were built more for prestige than defence. That said, during the fourteenth century the whole region would have been quite poor and yet has twenty pele towers which perhaps indicate sthe problems at that time with regular raids from the north.

The pele tower in Kentmere was owned by the Gilpin family who had owned land in the area since the reign of King John and in 1215 Richard de Gipin accompanied the Baron of Kendal to Runnymead where the Magna Carta was sealed. In the sixteenth century Bernard Gilpin was known as 'The Apostle of the North' for the many kind acts he performed feeding and looking after the poor and needy in the area. It is said that on one occasions a thief, who had stolen his horses, returned them at once when he heard who they belonged to.

Remains of dugout boat at Kendal Museum.

Kentmere Hall.

Yewbarrow (or Ubarrow) Hall.

Kentmere valley.

The pele tower in Longsleddale (now listed on maps as Yewbarrow Hall) was built by the de Leybourne family, a powerful local family one of whose ancestors was once the Sheriff of Cumberland. Since then both pele towers have had additional buildings added and are now privately owned, though both have remained relatively unchanged over the past few hundred years and are an attractive reminder of more turbulent times.

Recent History

For such quiet and picturesque valleys the recent history is surprisingly industrial with paper mills, bobbin mills, lead mining and slate quarrying plus the diatomite mine mentioned earlier. It was also pretty rowdy and the Low Bridge Inn in Kentmere was the first pub in England to lose its licence in 1887 for being 'too far from police for supervision'. There had been a pub on that site for over 300 years but the rowdy antics of the quarry workers, blowing their wages on the way home, attracted the attention of the powers that be in Kendal, who refused to renew its licence. The owners took their case all the way to the House of Lords where they ultimately lost but the precedent set (Sharpe V. Wakefield) established the absolute discretion for magistrates to grant or refuse a licence.

In the 1840s the River Kent powered seven watermills along its course including Fellfoot Mill which at the time was claimed to be the biggest bobbin mill in the north. Bobbin making dominated what is now south Cumbria and at one point there were over seventy mills in the area, largely providing bobbins for the mills in Lancashire.

Lead mining took place on a small scale, as did slate mining and the mining of limestone to produce lime for improving the quality of the fields; there were eight quarries in the Kentmere valley alone. Although Westmorland slate may never have rivalled Wales in terms of volume, its distinctive green hue and high quality meant it was much in

Wrengill Quarry near Longsleddale.

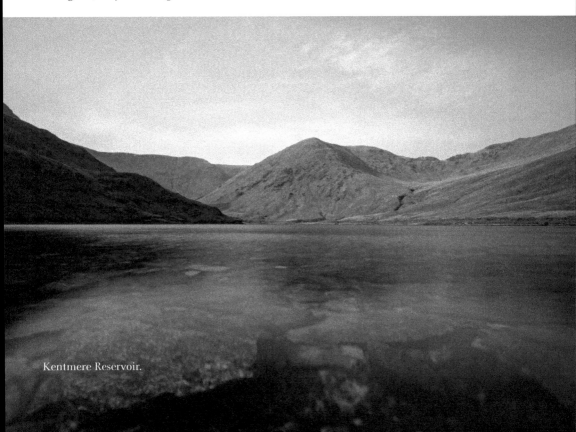

Kentmere Reservoir.

demand. Sir Christopher Wren specifically stipulated the use of Westmorland slate in the construction of Chelsea Hospital and Kensington Palace.

Working the mines and the quarries would have been heavy work and once the materials were extracted they needed to be hauled along the valleys by horse and cart to reach the Old North Road (see chapter one). This inaccessibility meant that the local mines gradually lost out to larger, more efficient and better placed sites elsewhere.

Farming is perhaps the most consistent industry in the area, though that too has gone through many changes. Draining the tarn and other drainage improvements in the first half of the nineteenth century meant that there was an inconsistent flow along the river; which caused problems for the mills depending on it. This ultimately resulted in the building of Kentmere Reservoir at the head of the valley in 1845 in order to regulate the flow to the watermills throughout the year.

The diatomite in the bed of the old tarn was mined from 1930 through until the 1970s when, as with the previous mining activities in the area, it became uneconomical to continue. It was transported using an aerial ropeway; the remains are still noted on maps but in reality are hard to find and although it sounds as if it would have been a blot on the landscape one guide from 1937 describes it as being '... hidden by woods from any viewpoint but its immediate entrance'.

Over the centuries there have been many famous names associated with both Kentmere and Longsleddale, but few are better known than Postman Pat. John Cunliffe, who wrote the books, lived in Kendal and based Pat's imaginary village of Greendale on Longsleddale. Next time you visit take a closer look at the small stone bridge at Sadgill and you'll be instantly transported back to your childhood.

Sadgill 'Postman Pat' bridge.

Whitehaven and St Bees

Many people wouldn't describe Whitehaven as beautiful, but if they stood on the harbour on a clear day with the waves crashing all around and looked at the stunning views across the Solway to Scotland, they might just change their mind.

Natural History

St Bees is the only cliff on the whole of England's north-west coast and it marks the starting point of Wainwright's Coast to Coast walk (which finishes 192 miles away in Robin Hood's Bay). The sandstone cliffs are over 295 feet high (90 metres) and run for four miles, most of which are protected by SSSI status (Site of Special Scientific Interest) – perfect if you don't fancy walking all the way to Yorkshire.

The cliffs are home to the largest colony of seabirds on the North West coast with over 5,000 pairs nesting during the spring and summer, when you should be able to spot kittiwakes, guillemots, razorbills, fulmars and the occasional seal from the RSPB viewing platforms along the clifftops. If you're there in May and June you might be lucky enough to spot a few puffins and, if you're really lucky, a black guillemot (this is the only place where they nest in England).

The lighthouse at St Bees Head was built in 1718 and is a reminder that the rocks have caused untold problems in the past, with many of the unfortunate souls who perished being buried at the priory church. One grave, built for eleven souls that perished when an Italian ship sank in 1879, is covered in seashells and has been for as long as anyone can remember.

Carboniferous coal deposits dominate the area and had a huge impact on the industrial history of the town and the rocks on the seashore at Whitehaven are one of the only places in the country where rare Carboniferous plant fossils can be collected on the coast. Iron ore was plentiful too and a magnificent piece of haematite (iron ore) is on display in the Beacon Museum on the quayside with a large 'Please Touch' sign next to it so you can get a real feel for the smooth knobbly nature of this gorgeous mineral.

Many of the local quarries have become havens for wildlife. One great example is Clints Quarry just to the south of the town which really is a perfect 'secret garden'. From the 1600s right through until 1930 limestone was quarried there and then for fifty years or so Mother Nature was left to her own devices. The quarry is now owned and managed by Cumbria Wildlife Trust as a nature reserve.

From the road all you see of the site is a narrow muddy track leading along what used to be the old railway lines but, if you follow the track, after 100 or so you'll find yourself in a beautiful sheltered oasis which in the summer is covered in meadow flowers such as bee orchids, wild thyme and ox-eye daisies and awash with a good variety of butterflies and dragonflies. Look out for the ant hills too; yellow meadow ants thrive here and do an excellent job of churning the soil and distributing seeds.

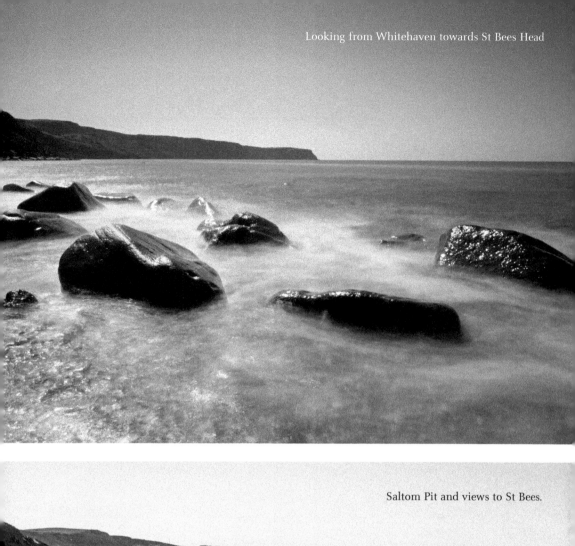

Looking from Whitehaven towards St Bees Head

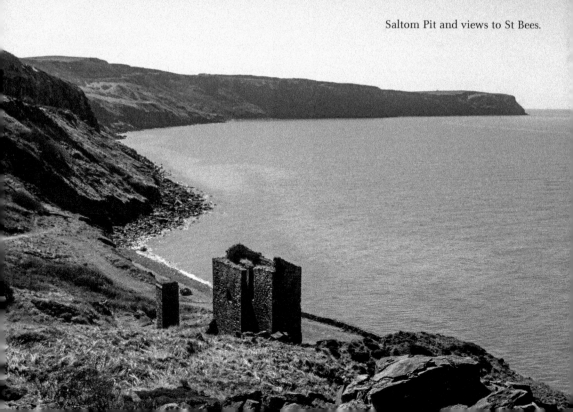

Saltom Pit and views to St Bees.

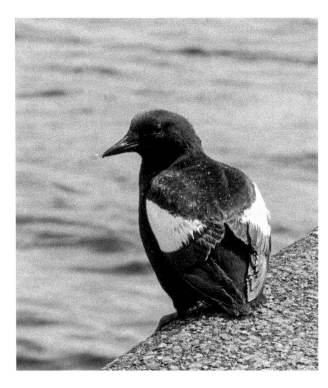

Left: Black guillemot.

Below: Whitehaven harbour at sunset.

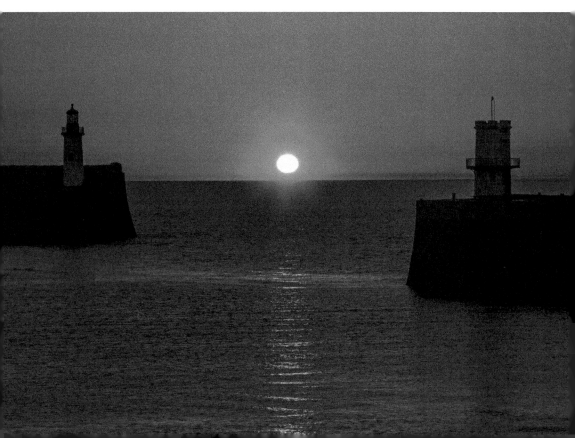

Right: Common spotted orchid, Clints Quarry.

Below: Clints Quarry 'Secret Garden'.

When it was first left to its own devices the quarry was self-managed, with a huge population of rabbits keeping the undergrowth at bay. However after myxomatosis wiped them out, Mother Nature needed a helping hand so these days the undergrowth is kept under control by an army of conservation volunteers and the grazing of Jacob sheep during the summer months.

The old drainage pools in the quarry are home to Palmate newts and provide perfect conditions for spawning frogs and dragonfly larvae, though it's a delicate balance easily knocked out of kilter. When fish were accidentally introduced into one of the pools they wiped out a group of great crested newts which had previously thrived there.

Another issue affecting this fragile ecosystem is people sneaking in to hold bonfire parties. The problem isn't just the rubbish left behind; the ash from the bonfires enriches the surrounding soil and has a negative impact on the native plant species which thrive in nutrient poor conditions.

Early History
There's evidence of man in this part of Cumbria going back to Neolithic times (4000–2500 BC) when people would have lived as farmers raising crops and tending cattle. The best relics from this period are the spectacular stone circles such as Swinside to the south and Castlerigg to the east. The beaches provided a plentiful supply of flint (not native to the area but bought in by the ice sheets during the last ice age) which early man turned into axes and other small tools.

After the Romans left around AD 500, this part of Cumbria lived in relative peace until AD 670 when the Angles arrived from Germany. They were followed in AD 876 by the Scandinavians and the Vikings who, despite their fearsome reputation, simply settled here to farm and raise their families. In 945, after the battle where King Dunmail was defeated (chapter five), King Edmund of England gave Cumberland (what is now roughly the north of Cumbria) to Malcolm of Scotland and it remained in Scottish hands for the next 150 years or so – right through the Battle of Hastings and the writing of the Domesday Book, which explains why the towns and villages in this area don't get a mention despite existing at that time.

Over in St Bees the legend of St Bega (after whom the village is named) tells us that she arrived sometime between AD 600 and 900. She'd fled from her home in Ireland to avoid having to marry a man she didn't love and her tiny boat was washed up on the shores of what is now St Bees. The story goes that she lived as a hermit and cared for the local people. When she moved on she left behind an arm ring which was looked after by the monks who founded the priory in 1120. They passed down her story until the monastery was dissolved in 1539, at which point both the arm ring and the story became the stuff of legend.

The barony of Copeland (the district surrounding Whitehaven) was created in the early twelfth century by Henry I and was administered from Egremont Castle ,just to the south. At this time Whitehaven was a small fishing village but the land it stood on was owned by the powerful priory at St Bees. Following the Dissolution of the Monasteries much of the land around Whitehaven was bought by the Lowther family and in the early 1600s Sir Christopher Lowther spotted the opportunity to mine the local coal and ship it to Ireland. This was a great success and his son Sir John Lowther went on to expand the coal mines and shipping industries and the population of Whitehaven grew from 250 people to over 2,000.

Successive members of the Lowther family continued to develop the coalmining enterprises and expanded into building the ships needed to transport the coal and the many other products which were now being traded through the port. Accordingly the harbour grew in size and importance and during the early eighteenth century Whitehaven became one of the busiest and most successful trading ports in the country.

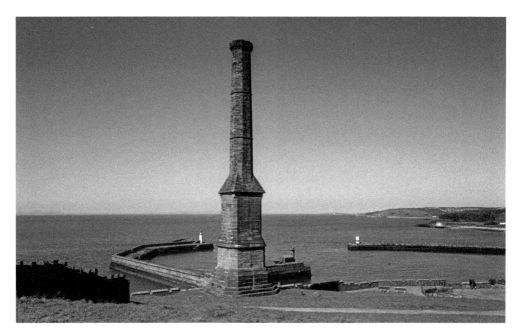

Candlestick chimney, Whitehaven harbour.

Recent History

Whitehaven was one of the first ever planned 'new towns' and its grid-like positioning of streets is thought by many to have inspired the layout of New York's street pattern. In 1964 the Council of British Architecture designated Whitehaven a 'gem' town (one of only fifty-one in the country), protecting not just the buildings, but also the historical road layout.

Compared to other coal mining areas the coal reserves in Whitehaven were not huge, but they were of very good quality and around 100 square miles of coal were worked, including the world's first major undersea coalmine, Saltom Pit, which was built between 1729 and 1731 to extract coal from a seam which ran out under the Irish Sea. The town also boasted King Pit which in 1793 reached a depth of 160 fathoms (293 metres), making it the deepest pit in the world at that time.

The coal was so plentiful that it often outcropped at the surface and was washed up onto the beaches where the poor would go and collect what they could to make use of the free fuel supply. You can still find coal on the beach today, though few people now collect it.

Although the seams were of good quality and up to 13 feet thick in places, they were also very rich in the poisonous and highly explosive gas methane. This meant that out of necessity many of the earliest safety features and devices used in mining were discovered and used for the first time in Whitehaven, including gas detectors and the first ever form of gas mask. Despite all of that there were inevitably accidents and disasters. In all over 1,700 lives were lost in the pits before the final shaft, Haig Pit, closed in 1986 (now reopened as a mining museum). The worst disaster in the area was in 1910 when 136 men lost their lives in an explosion in Wellington Pit.

One prominent reminder of the mining history is the large 'Candlestick' chimney high above the harbour which was once part of Wellington Pit. Reputedly modelled on a candlestick owned by the Lowther family it was retained when the pit was demolished, but not just for aesthetic purposes: it continues to act as an escape vent for methane gas still being given off by the pit below.

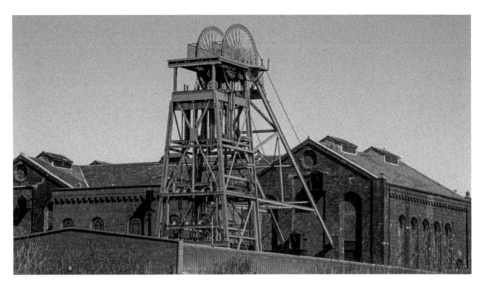

Haig Pit.

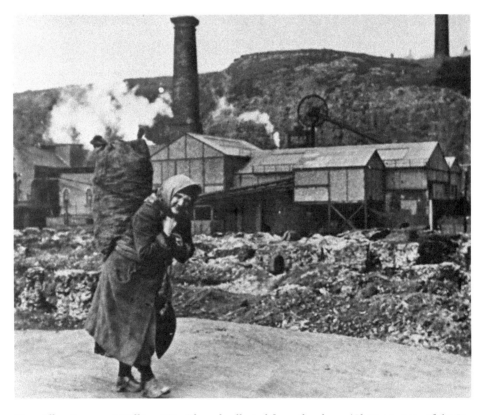

Mary Ellen Spence at William Pit with coal collected from the shore. (*Photo courtesy of the Rex Malden Collection & Haig Pit Museum*).

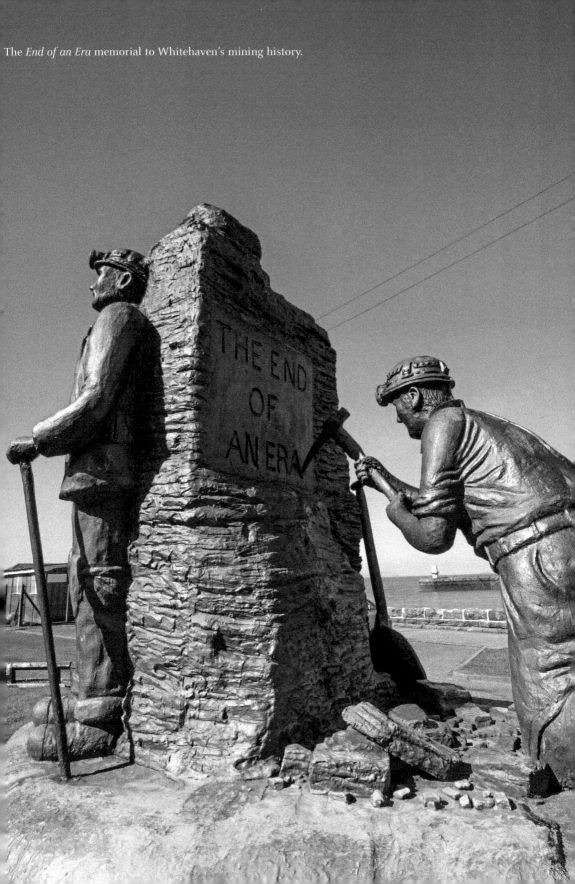

The *End of an Era* memorial to Whitehaven's mining history.

During the seventeenth and eighteenth centuries many of the ships sailing from Whitehaven followed what was known as the Trade Triangle. They left Whitehaven loaded with local produce and sailed for West Africa; there they traded some of their goods and loaded their ships with slaves before setting sail for America. Once in America they sold their slaves and remaining provisions, using the money to buy rum, molasses, coffee, tobacco and cotton before heading home again.

Whitehaven was the fifth most active port in the slave trade (behind Liverpool, London, Lancaster and Glasgow) but they struggled to make the profits of Liverpool and London due to the remote location and no slave ships sailed after 1789. Coupled with the loss of the tobacco trade to Glasgow and finally the American War of Independence, by 1790 shipping trade had pretty much ceased in the town.

Talking of the American War of Independence, John Paul Jones brought the war all the way to Whitehaven. He was born in Scotland and began his naval career in Whitehaven before emigrating to America, where he joined the Continental Navy (precursor of the US Navy). On 23 April 1778, as captain of the USS *Ranger,* he launched an attack on Whitehaven, planning to set fire to their entire shipping fleet. He ultimately failed when residents raised the alert, though he went on to become one of the most celebrated names in American naval history, but that's not the only American connection for Whitehaven; Mildred Warner Gale, grandmother of first US president George Washington, was from Whitehaven and is buried in the town at St Nicholas' church.

Whitehaven became well-known for building ships as well as sailing them and for over 200 years from 1650 the ship-building industry thrived and built some of the best known ships of that era. Sadly the remote location and shallow waters worked against them meaning they couldn't deliver the bigger ships demanded, and in 1889 the shipbuilding industry ended.

That wasn't the end of Whitehaven's contribution to British history however; during the Second World War nearby Holmrook Hall was home to a secret Royal Navy bomb disposal school known as HMS *Volcano*, where men were trained to deal with German Teller mines in preparation for the D-Day landings. Locals were told by officials that it was requisitioned as a recuperation facility for injured or shipwrecked sailors. Following the war the hall was deserted and eventually demolished.

Langdale Valley and Great Gable

The Langdale valley is possibly one of the most visited valleys in the whole of the Lake District and it's also one of the few large valleys which isn't dominated by a lake. The Langdale valley has something to offer whatever your level of adventure; gentle family strolls along the broad footpaths of the valley floor, slightly more challenging rambles along Stickle Ghyll and Dungeon Ghyll, decent hikes up and over the fell tops or full-on mountaineering pitches on Pavey Ark or Gimmer Crag, and all of it with a fine selection of pubs on hand.

Natural History

Though the shape of the Langdale valley has changed very little over the millennia, farming, the Second World War, and the rise and fall of the Industrial Revolution have had a big impact on the land usage, which in turn has had a significant effect on the wildlife.

The woodlands along the valley sides were once closely managed with barely a twig going to waste. Many of the trees were coppiced with the wood used for making charcoal and the bark used in the tanning process. The bobbin mills at Ambleside, Staveley and Stott Park also made use of the coppiced wood, as did the brush works in Kendal. Hazel was sent further afield to Staffordshire for basket weaving and any leftover twigs were bound together and sent to Barrow, where they were used as part of the steel manufacturing process.

Local residents who remember the old woodlands recall hazel trees that were so loaded you just had to shake them and the nuts fell down like confetti; even the bracken on the local hillsides was put to good use and harvested every autumn for use as animal bedding.

The local woodsman was employed to keep an eye on things and would thin out any areas of overgrowth and perhaps make a little money on the side selling broom handles to local farms. The woods are still a great place for birds such as wood warblers, willow warblers, red starts, tree pippets and the greater spotted woodpecker. Even if you're not familiar with them, the combined sound of their voices provides the perfect soundtrack to any woodland stroll.

Coppicing stopped in the 1960s and for a while the woodlands were neglected, one possible side effect being a decline in the number of red squirrels. Coppicing creates vigorous growth and a more plentiful supply of nuts than is found in older trees and many folk who have lived in the valley their whole lives noticed the decline in red squirrel numbers when the coppicing stopped. The good news is that coppicing is now restarting in an effort to reinvigorate the woodland, so hopefully that trend can be reversed.

As well as the woodlands, the open farmlands have also gone through a lot of changes. Prior to the Second World War the valley was full of flower-rich meadows which were all managed naturally and though that sounds idyllic, it was a lot of hard work. Manure was spread across the fields by a man using just a horse and cart and a shovel, though even

Above: The Langdale Pikes from the Langdale valley.

Left: Bobbin Mill furnace.

Above: Bobbins.

Right: Red squirrel.

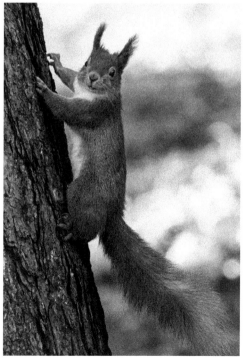

that was a lot less hazardous than spreading lime. The lime, from the many lime kilns in Cumbria, was needed to improve the quality of the soil and was deposited in large dusty piles across the fields. Once it had rained and the lime was 'slaked' it was the job of the farm boy to shovel it and spread it across the fields, though he had to watch out if he found a pocket of unslaked lime as it would eat away at his clothes and burn his skin.

These beautiful grassy meadows were used to make animal feed for the winter months, but that changed during the Second World War when the emphasis was on using every available space for food production. The fields were ploughed up and planted with potatoes to support the war effort. After the war more intensive farming methods were brought in and the use of herbicides and commercial grass seed improved the yield of the meadows but meant fewer flowers, which in turn had an impact on the variety of butterflies and other insect life. Thankfully this is something which is also now being addressed by careful land management, balancing the needs of the farmers with the protection of the natural habitats.

Early History

Some sources have suggested that the Langdale Valley is the oldest inhabited place in the Lake District; I think it's possibly more accurate to say that it's one of the places where we have the most evidence of early man.

No account of the early history of the Langdale Valley is complete without mention of the Neolithic axe factory, the axe heads from which have been found as far afield as Northern Ireland and Lincolnshire, providing evidence not only of early man's skill with tools but also their ability to trade and travel. Although there are many examples of axe heads (a good selection of which can be seen in Kendal Museum), what are very rarely found are the wooden handles or leather pouches which are likely to have gone with them.

The axe heads are made from a narrow vein of distinctive volcanic rock (known as green tuff) occurring high up in the fells. Many old axe heads, rejects and other debris have been found in the screes near Pike of Stickle and the variety of shapes and forms found suggests they may have been sharpened, tweaked and adapted for different purposes. There are also some which have been highly polished to show off the grains in the stone and it's possible they were made purely for decoration or as indicators of wealth and status. Over the years they have gained mystical significance with some people and up to a hundred years ago local farmers would place them in water troughs to guarantee the health of their stock.

There are also some excellent examples of ancient Neolithic art in the valley, perhaps the best known is the one at Copt Howe near Chapel Stile where the swirling patterns and concentric circular designs seem to be an ancient code just waiting to be deciphered.

Aside from the axes another major influence on the area were the ancient Norse settlers and again there is much evidence of them to be found both in the place names and the geography. Near to what is now Fell Foot Farm is a large earth mound which is believed to have been a 'Law Ting' – a place where the Vikings would have held open air assemblies to discuss local affairs and govern the land.

While the 'Law Ting' is little more than a mound of grass these days, the impact of the ancient settlers on the local dialect is still very much in evidence. Sheep counting in particular has its own language going right back to the Vikings and many farmers to this day still count sheep using *yan, tan, tethera, methera, pimp* for one, two, three, four, five respectively.

So embedded was this ancient Norse dialect that there is a story of a local man with a strong Cumbrian dialect who was stationed in Iceland during his time in the Royal Navy in the Second World War. He apparently managed to communicate with the locals in their own language with very little trouble at all; pretty impressive considering the Vikings left a thousand or so years earlier, but also a little sad that this dialect is now dying out.

Neolithic axe heads at Kendal Museum.

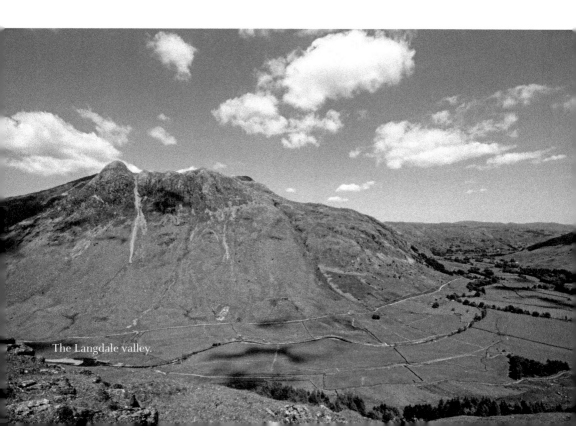

The Langdale valley.

Recent History

The Lake District is considered by many to be the birthplace of British rock climbing and, that being the case, surely the Langdale valley and surrounding fells are its epicentre? Challenges such as Napes Needle on nearby Great Gable, the Central Buttress on Scafell and Gimmer Crag, the huge solid slab of rock high up in the Langdale Pikes, have drawn climbers since the sport first began in the late 1800s.

Mountaineering greats of the twentieth century such as Sir Chris Bonnington, Doug Scott and Reinhold Messner (the first man to climb all the mountain peaks in the world above 8,000 metres) were drawn to the Lake District not for its immense size but for its technical difficulties. The area isn't just about the big names though; it's also about the pioneers.

Napes Needle, a huge pinnacle of seemingly impenetrable rock, was first scaled in 1886 by W. P. Haskett-Smith, who proudly declared that he had done it without the aid of ropes or 'other illegitimate means' and is said to have performed a hand stand on the summit. He left a handkerchief on the top as evidence he'd made it, though I doubt it's still there. Even today Napes Needle, classed as 'Hard Severe', is feared and revered and continues to attract world-famous climbers.

Siegfried Herford was the first person to conquer the central buttress on Scafell in April 1914, a route described by the Fell and Rock Climbing Club (FRCC) as being the most arduous ascent in the Lake District and ranking among the hardest in the world. Herford later enlisted in the Royal Fusilliers and was sadly killed by a grenade in January 1916.

A guide book from the mid-1800s describes the head of the Langdale Valley in these foreboding tones: 'Over the bridge thus formed ladies have been known to possess the

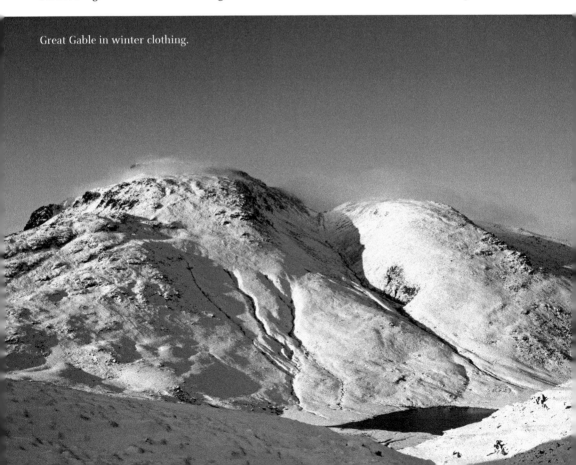

Great Gable in winter clothing.

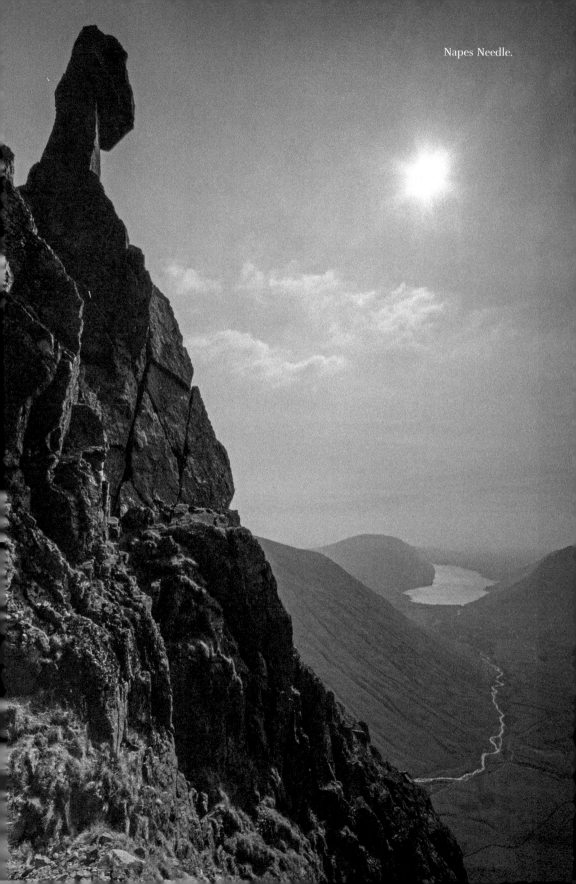

Napes Needle.

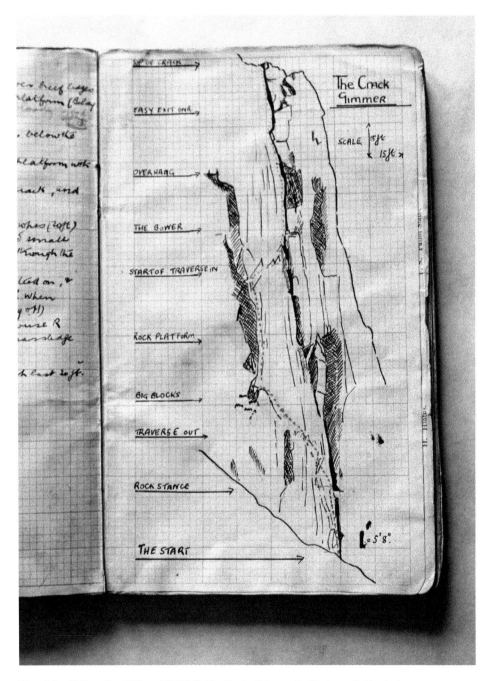

Sketch by C. Douglas Milner, FRCC Guide Book. (*Mountain Heritage Collection*).

Great Gable war memorial.

intrepidity to pass'. One such intrepid lady was Mabel Barker who grew up within sight of the Lakeland Fells. Her sense of adventure and friendships with climbers of the day led her to become one of Britain's first female rock climbers and only the fourth person (first female) to climb the infamous Central Buttress on Scafell.

Sketches from old notebooks are works of art and show how mountaineers pored over their routes, planning them in meticulous detail before setting out, belying the notion that they are feckless daredevils. This sketch of Gimmer Crag from the 1930s by C. Douglas Milner (climbing partner of Haskett-Smith) shows their route in detail and yet would still look good framed and hanging on the wall.

The FRCC was formed in 1906 by a group of climbing enthusiasts and was unique at the time for being open to men and women. Sadly, the club lost one third of its members during the First World War. In the following years they purchased 3,000 acres of land around Great Gable and on 8 June 1924 they held a service on the summit of the mountain to unveil a plaque commemorating those who had died, including Siegfried Herford. They handed the title deeds of the land to the National Trust to protect the land and every year on Remembrance Sunday hundreds of people gather at the memorial on the summit of Great Gable to pay their respects and remember those who have died in conflicts around the world.

As well as rock climbing, the area was also famous for the brewing of illegal liquor. The most famous distiller was Lancelot 'Lanty' Slee, who farmed by day and brewed by night. He often found himself in court for his illicit activities but, as many of the local magistrates were his best customers, he generally escaped trouble. He took the location of his illegal stills to his grave, though one was found in a nearby cave after his death and remained well preserved until it was plundered in the 1960s.

Barrow-in-Furness and Walney Island

Barrow-in-Furness has been the punch line to many jokes and is probably not high on many people's 'places to visit' list. It's true that it's not the prettiest town in Cumbria, but it's surrounded on three sides by sea and the only side that doesn't have a coastline has the Lake District so it has plenty to boast about.

Natural History

The geology around Barrow not only affected the development of the town but also had a huge impact on the development of the southern half of the Lake District. As well as the commercially important deposits which could be used in the iron and steel industry, the natural protective barrier of Walney Island screens Barrow off from the worst the Irish Sea can throw at it, making it a safe and desirable harbour.

Not that Walney's only claim to fame is that of protective barrier. Its long sandy beaches are a real hidden gem; Sandy Gap in the middle of the island is a particularly lovely spot and serves as the start of the 81-mile Morecambe Bay Cycleway; then there's the views from the nature reserve at South Walney, which are hard to beat with Piel Island and the whole of Morecambe Bay to the south and the commanding presence of Black Combe rising up to the north. At high tide the bird hides on the end of the nature reserve are the perfect place to sit and watch the grey seals as they swim in the nearby bay.

If you're planning to visit you do need to check before venturing onto South Walney; the big storms of the winter of 2013/14 eroded significant chunks of coastline and during particularly high tides the reserve can be cut off for up to four hours. Ever since the last ice age changes in sea level have had an impact on the area; at very low tides the remains of an ancient forest can be found off the shores of Walney, evidence of lower sea levels and changing climates.

South Walney is part of the Morecambe Bay Special Protection Area (SPA) and is a haven for breeding birds. The island is home to 4,500 breeding pairs of lesser black-backed gulls, but this has dropped dramatically since the 1970s when there were as many as 40,000. In an effort to understand what might have caused this, Cumbria Wildlife Trust have fitted tiny solar powered trackers to a number of birds to monitor their habits and they've made this information available in real time on their website.

If you enjoy living dangerously you could try visiting the reserve during the late spring when the herring gulls are nesting. Notoriously large and feisty creatures, they're quick to swoop down on you if you stray too close to a nest – best advice is to wear a hat and take advantage of the 'bird scarer' stick on offer at the warden's hut.

There are many less territorial birds to spot throughout the year, though summer is a particularly good time to visit when the eiders are in residence with their unique and comical call. As well as the eiders you should easily be able to spot a wide variety of waders and a good selection of warblers.

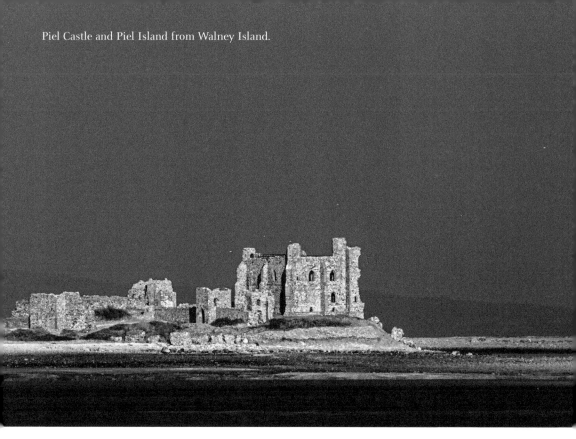

Piel Castle and Piel Island from Walney Island.

Walney lighthouse.

Grey seal near Walney Island.

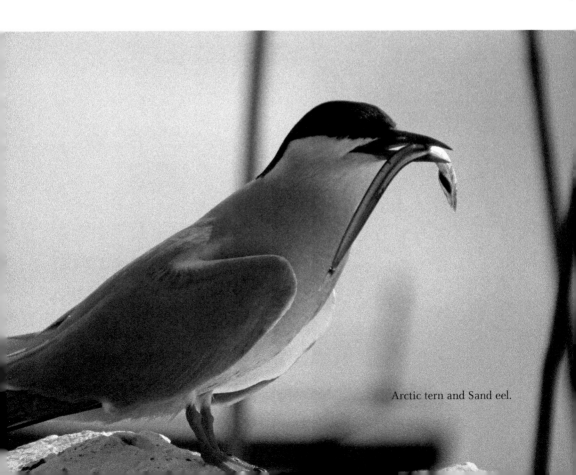

Arctic tern and Sand eel.

During the summer months, nearby Foulney Island becomes home to a colony of nesting terns but they have their work cut out for them. It's a relatively small colony but it still attracts the attention of the nearby kestrels who have been known to wipe out several clutches of eggs. Usually terns nest in much larger colonies and their mighty numbers are enough to see off the kestrels, but sadly not here. The wardens do all they can to protect the terns, and dogs are not allowed on the island throughout the nesting season.

Early History

Assorted finds of primitive flint tools have been well documented on Walney Island. The flint, which is evident as pebbles across the beaches of Walney, is not native and was brought down by the same ice sheets that left the flint deposits in Whitehaven. There have been many ancient pottery finds from the same era too, some of which can be seen at the nearby Dock Museum.

It isn't just recent man that's responsible for the metal deposits in the area – there are numerous examples of Bronze Age man producing weapons and tools to make their life easier. It's likely that at this time the area was extensively farmed and the nearby rivers and sea would have provided perfect opportunities for trading goods with Ireland and beyond.

Did the Romans ever come here? Well, there's not a lot to indicate they settled here but the evidence which has been found, including a very rare and beautiful bracelet, would suggest that they traded with the area at the very least and, given the natural protection of the harbour, it would have been surprising if they hadn't used it as a port at some point.

Both the Angles and the Scandinavians left their mark on the region, but the most important influence on the early history was Furness abbey, built from the local red sandstone. Norman monks founded the abbey in 1127 after the land was given to them by Stephen, Count of Blois (later King of England), and twenty years later the abbey was incorporated into the Cistercian order, which was when things really took off.

The monks ran a two-tier system with the choir monks being the ones who did most of the religious duties and the lay monks taking care of all the heavy work and manual labour. The abbey grew to be one of the most powerful in the country, owning large swathes of land across the North West, including areas on the Isle of Man.

The local people paid a tithe to the abbey and in exchange the abbey governed the area with the abbot holding court at Dalton where he settled disputes and enforced the local laws. Part of that tithe may have taken the form of labour; Walney was farmed by the monks and the remains of a dyke at Biggar is likely to have been something the locals were expected to repair and maintain.

The abbey saw off many Scottish raids during medieval times including one raid in 1322 by Robert the Bruce. During this particular raid he was apparently entertained by the abbot ,who paid a ransom to ensure the district was not plundered in the future.

Perhaps the most surprising thing about the monks is the amount of smuggling they were involved in. They ran a busy import and export business from Piel Island, exporting wool and other goods and importing wine, and all of it without paying the requisite taxes. Piel harbour was the deepest natural harbour in the area and of course it didn't hurt that it was a little more remote than the abbey. The castle on the island was most likely built by the monks around 1327 to protect their business interests and trading routes.

A local rumour persists that there is a secret underground passage from the abbey out to Piel Island. It would have been a remarkable feat of engineering for the day had they managed to build it, and no evidence has ever been found to support the claims, but that doesn't stop it being a fabulous piece of local folklore.

Both the abbey and Piel Castle were already in decline before 1537 when Henry VIII ordered the Dissolution. Very soon lead was robbed from the roof and the stone used in local

Furness abbey.

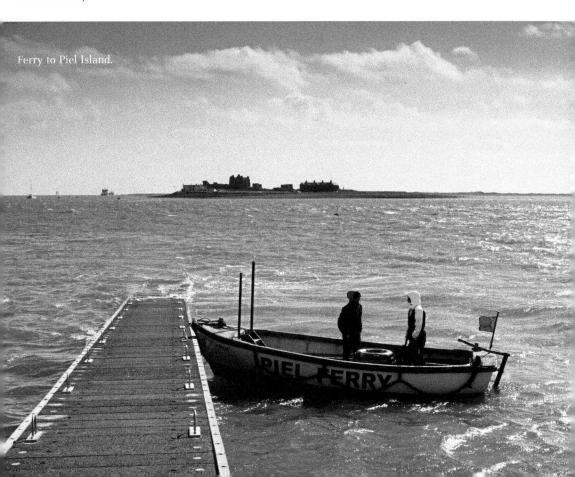

Ferry to Piel Island.

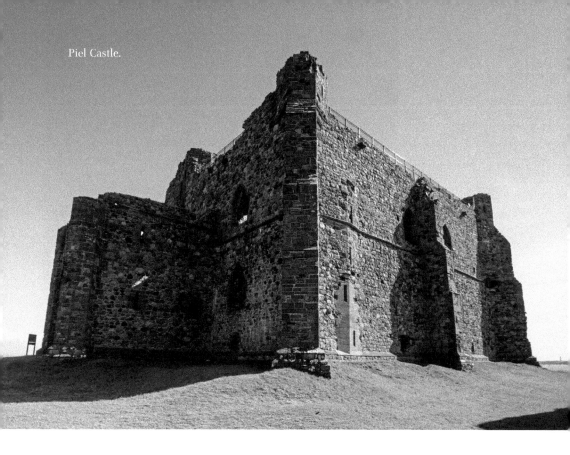

Piel Castle.

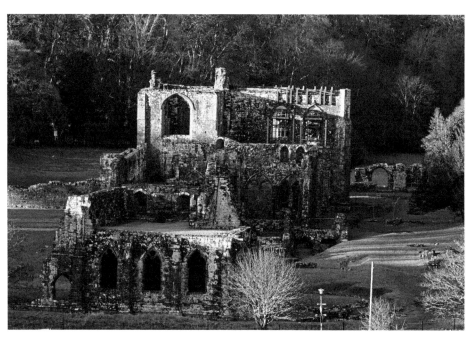

Furness abbey.

buildings, leaving us with the dilapidated but beautiful remains we see today which are now, thankfully, in the care of English Heritage. whose work to preserve them is much in evidence.

Recent History

Hold onto your hats because the recent history of Barrow whistles along at a spectacular rate! Prior to the 1800s Barrow were little more than a sleepy fishing village. In 1851 the population of the town was 450 and by 1881 it had exploded to over 47,000.

It all starts with William Cavendish, Earl of Burlington (later to become the 7th Duke of Devonshire), who owned a slate quarry at Kirkby-in-Furness and an iron ore mine in Lindal. The slate and the iron ore was moved from his quarries by horse and cart to the small docks which then existed in Barrow. This was time-consuming, tricky and unpredictable in winter so when the railway revolution hit he was quick to embrace it.

He joined forces with James Ramesdon (later to become the first mayor of Barrow) and together they bought up large amounts of land in the area. They improved the docks and associated industries and were responsible for the building of the Furness Railway, which opened on 3 June 1846. Initially it existed solely to transport materials from Kirkby and Lindal to the docks at Barrow, but in 1850 it extended north to join the line to Whitehaven and in 1857, thanks to the building of the Kent and Levens viaducts, it connected right across the south of Cumbria to link Barrow directly into the heart of Lancashire.

The arrival of the railways led to the spectacular growth of the town but as it grew it suffered from dreadful overcrowding; houses and tenement blocks were built at such a rate that pretty much the entire town was a building site and the majority of these new homes were owned by the board and backers of the Furness Railway Co. It was a purpose-built new town and its purpose was to turn a profit.

Soon, associated industries popped up; iron works and a steel plant which was among the biggest in Europe, dominated the skyline belching smoke and creating huge piles of slag, all of which contributed to building Barrow's reputation as a hard and dirty town.

The first ship built by the Barrow Ship Building Company was launched in 1873. beginning Barrow's proud ship-building industry. In 1897 the company was bought by Vickers and, although much reduced, shipbuilding continues to this day, now under the ownership of BAE Systems. It is one of the very few shipyards to have remained in operation in England, with its isolation forcing it to be more self-sufficient and able to provide ships complete with machinery, munitions and other essential equipment.

Following every boom there is usually a bust and this was no exception. Improved techniques for smelting elsewhere led to a drop in demand for iron and steel during the 1890s and the Furness Railway was hit hard. In an effort to generate income the owners turned to tourism and began running steamers from Fleetwood across Morecambe Bay to Barrow. The trains would carry tourists up to Windermere and Coniston where the railway company began the sight-seeing steamer cruises along the lakes which still run today. The Furness Railway was eventually amalgamated into the London Midland & Scottish Railway in January 1923.

For a town that owes so much of its existence to the railways, perhaps it's only fitting that one of the most famous railway engines of our time was born there. The island of Sodor in the iconic Thomas the Tank Engine books by Revd W. Awdry was based on Walney Island.

During the Second World War Barrow was hit very hard and the blitz of 1941 claimed ninety-two lives and destroyed over 600 homes. Surprisingly little damage was done to the docks and this is thought to be because the blackout confused the bombers, resulting in the rest of the town and surrounding village being hit. Given its industrial and battle-scarred past, it's not surprising that Barrow isn't as picturesque as a Lakeland village, but its isolation has bred a tough and resourceful population who may occasionally be down but are never out.

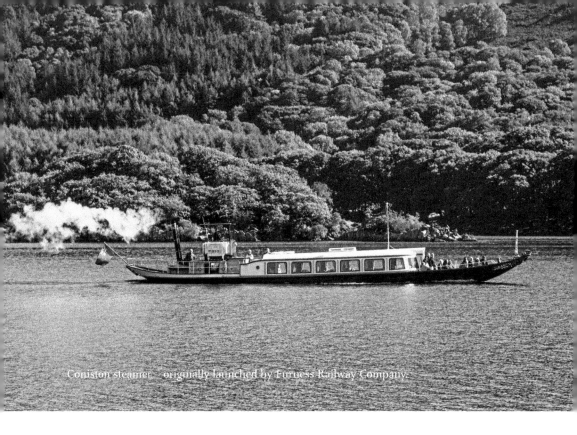

Coniston steamer – originally launched by Furness Railway Company.

Seabirds over Morecambe Bay.

Buttermere and Rannerdale

This is another chapter that puts our ability to sort fact from fiction to the test. Books, battles and beauty are the themes here, but hard facts become fewer and further between the farther back we go. Whatever the truth this is surely one of the most breathtaking valleys in the whole of the Lake District, with perfect low-level walks around Buttermere for those who don't fancy the big fells and a good few high-level yomps for those that do.

Natural History

As with much of central Lakeland, the stunning valleys and three gorgeous lakes (Buttermere, Crummock Water and Loweswater) owe their existence to the last ice age. Many people are of the opinion that where we now see Buttermere and Crummock Water there was once just one large lake and, looking at the geography of the valley, that would certainly make sense.

Rock-wise, this area is the place where the meeting of mudstones and silts with hot igneous intrusions created important mineral deposits and the classic green slate which is still mined up at Honister. The hydrothermal currents which occurred as the hot rocks were intruded created a unique feature known as the Crummock Water Aureole where the circulating water in the rocks leached out the original minerals but left behind a variety of others including calcium, iron, potassium and silicon, with the whole zone being cut through by tourmaline veins. The tourmaline is very rare and almost impossible to find but there have been a number of documented finds, particularly related to the other mining in the region.

Scale Force is tucked away on the far side of Crummock Water and is the highest waterfall in the Lake District, but you'll need your wellies if you plan to visit it as the trek round there can be rather boggy. Most waterfalls in the Lake District are known as a 'force' ,which is a throwback to the Old Norse word *fors*, meaning waterfall, and gives us some evidence that they are likely to have visited the valley.

In total the falls are 170 feet high (52 metres), but there are several smaller falls within the main drop with plenty of places to get a decent view of them. Both Wordsworth and Coleridge wrote about their beauty, but it's not just the falls themselves that are worth a look; as Scale Beck flows down towards the lake it crosses the striking red mudstones which, when set against the lush green valley and a clear blue sky, is absolutely breathtaking.

Down in the lake itself there are a wide variety of fresh fish including the rare arctic char, which enjoy living in deep, icy cold glacial lakes. A sizeable population have made their home here where they are protected and closely monitored.

One of the main products mined in the region was, and still is, slate. The Honister mine sits at the top of the pass leading down into the valley and it's likely that the distinctively beautiful green slate has been quarried here in some form going all the way back to the Romans and possibly before. Though there's very little in the way of hard evidence to

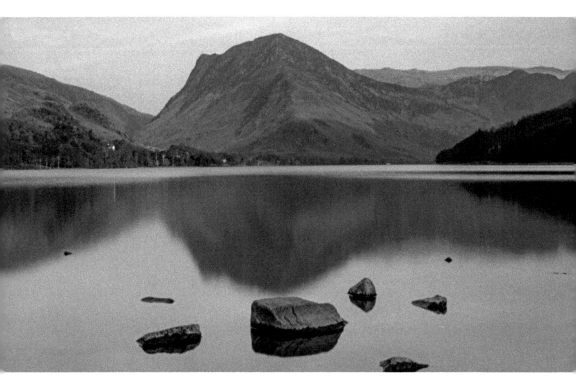

Fleet with Pike and Buttermere.

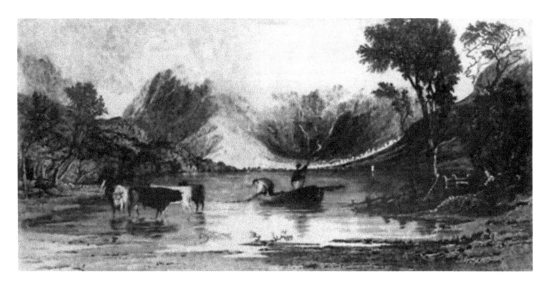

Farming and fishing in old Buttermere.

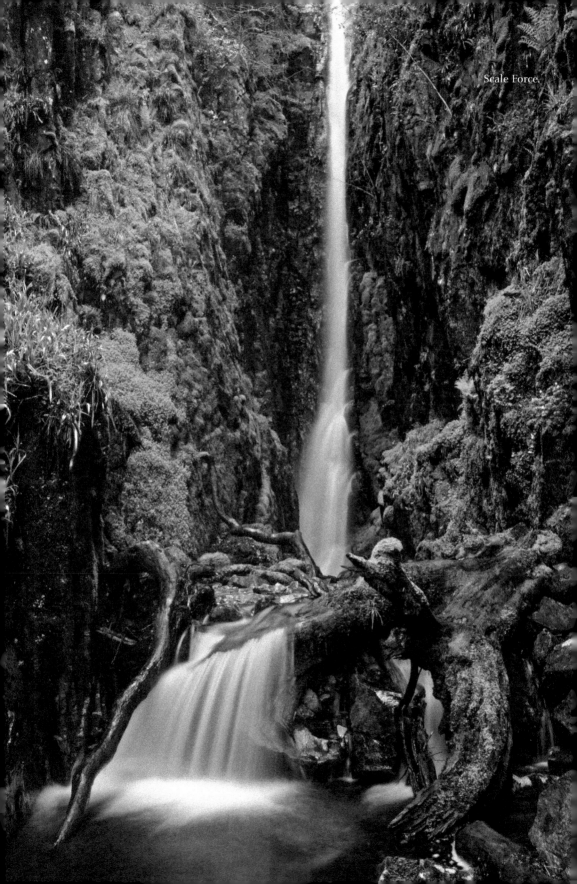

Scale Force.

Rannerdale bluebells up close.

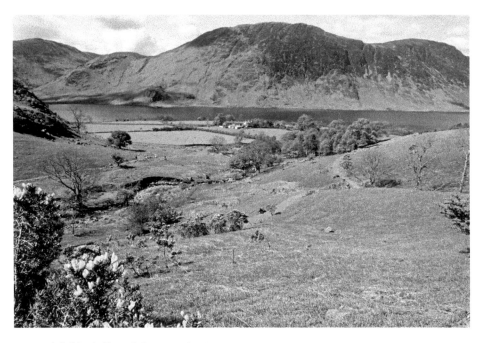

Rannerdale bluebells and Crummock Water.

support this, the rock outcrops at the surface and would have been very easy to access and use as a building material.

The Rannerdale bluebells are a spectacular natural phenomena and always attract the crowds. For a few glorious days each spring the open hillside behind Rannerdale Kotts is a carpet of brilliant blue. Of course there are many local woodlands where bluebells can be found, but it's the stunning spectacle of thousands of bluebells without a woodland in sight that make this view so special.

Ancient History

Local folklore tells of Jarl Buthar, who was a Norse leader with a secret stronghold in the valley. The story goes that he was behind a bloody resistance campaign which drove back the Norman invaders during the eleventh century.

He was known for his fearsome nature and guerrilla tactics which finally resulted in an almighty battle between Buthar's army and the Normans, known as the Battle of Rannerdale. It is thought that the name Buttermere is a derivation of 'Buthar's Mere' and legend has it that the famous Rannerdale bluebells grow in their unique position because they sprang from the blood spilled from the Norman army.

While many of the actual facts may remain forever a mystery, we do know that this was an area that is likely to have seen many battles during that period. In the years following the Battle of Hastings, Cumberland (which was still considered a part of Scotland at that point) was divided into a number of large baronies with the names of many, such as Allerdale, Egremont, Westmorland and Furness, still being familiar to us today. During that period many battles raged and as one force established itself from the south, so another

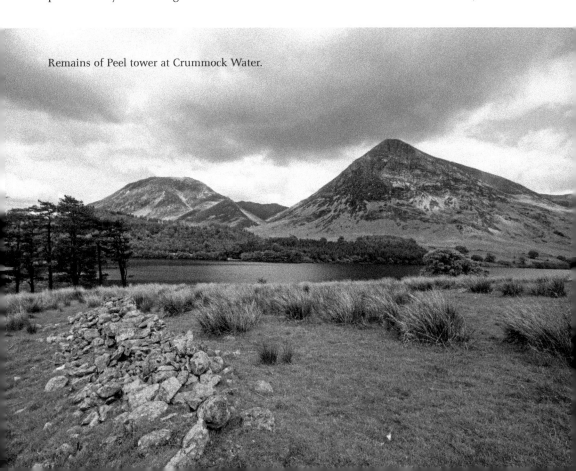

Remains of Peel tower at Crummock Water.

fought back from the north. Things didn't begin to settle down until the Treaty of York determined the current Scottish border in 1237.

At the northern end of Crummock Water are the remains of a twelfth-century pele tower which can easily be picked out on an OS map or aerial photograph. It is thought that the site was possibly a medieval manor and a series of ditches and moats has been identified on the eastern side, the western side being naturally protected by jutting out into the lake. From the records of St Bee's priory we know that there was a place of worship at nearby Loweswater during that time, on the site of what is now St Bartholemew's church.

In the *Magna Britannia* we learn that the population here has been somewhat sparse at times. In 1377 the population for the whole of Cumbria was 10,841 and in 1421 the MPs for Cumbria informed parliament that '... in all the county, within 20 miles of the border there are scarcely ten able men due to war, pestilence and emigration'. By 1688, although the population had risen to 66,375, the population for Buttermere and nearby Loweswater was listed as zero.

Though the area might have been light on people, it was heavy on sheep, and in particular the Herdwick, the sheep most associated with the Lake District. The name Herdwick is another word from our Norse ancestors and comes from 'Herdwyck' meaning sheep pasture; the sheep are often referred to as the ones with the smiley faces but they are also one of the toughest breeds on the fells and are able to survive on high pastures even throughout the winter months.

Back as far as the twelfth century and possibly even earlier, Herdwick lambs have been hefted by their mother; that is, they have been shown where to graze. The sheep you see on the fells today can trace their bloodlines back for generations. This isn't just an interesting fact, it's an essential part of farming in the region; the inbred knowledge of the sheep cannot be replicated and is one of the reasons that the Foot and Mouth crisis of 2001 was such a huge problem for the region. It thankfully missed the central fells though many thousands of sheep and cattle in the rest of the county were lost, including several irreplaceable pedigree bloodlines.

Of course not all sheep stay where their mothers tell them to and farmers' meets, which continue today, began as opportunities for farmers to return stray sheep to each other, much easier than the 100-mile round trip to the neighbouring farm each time one was found.

Recent History

The recent history of this part of the Lake District has been heavily influenced by books. In 1792 the book *A Fortnight's Ramble to the Lakes* was published by Joseph Budworth and in it he describes Sally of Buttermere, a young girl who worked in the Fish Inn whose real name was Mary Robinson. Among many other glowing tributes he said she '... looked like an angel; and I doubt not but that she is the reigning lily of the valley.'

This glowing description drew many tourists to the area, keen to see such a beauty; Wordsworth and Coleridge wrote about her and she became quite a celebrity. Eventually a gentleman claiming to be Col. Alexander Hope visited the inn, wooed and subsequently married the young and rather innocent Mary. Due to her celebrity the marriage was reported in the London papers, which led to 'Col. Hope' being recognised and unmasked as a con-man by the name of John Hatfield.

John Hatfield had conned many people out of money and had married Mary bigamously; he already had a wife and two children in Tiverton. He was caught, tried and eventually hanged for his crimes. Poor Mary returned to Buttermere where she became an object of ridicule, with even the poets now mocking her supposed lack of beauty. Things did eventually turn out well for Mary; she married a local farmer, moved out of the valley

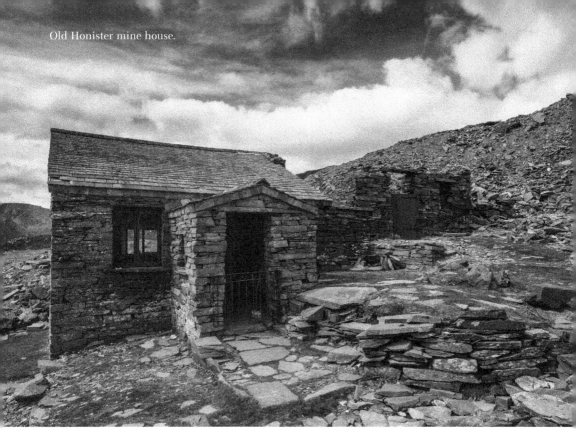

Old Honister mine house.

Moses Trod, leading towards Green Gable.

St James' church, Buttermere.

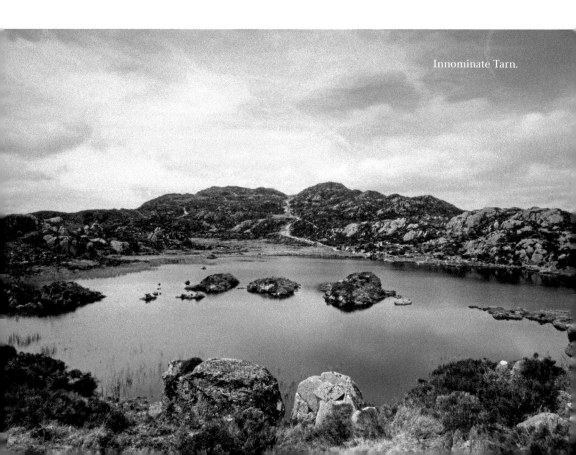

Innominate Tarn.

and had seven children before she died aged fifty-eight. Her grave can be found in the churchyard in Caldbeck.

The other books to have influenced Cumbria's recent history are those of Alfred Wainwright. A. W., as he was known, was born in Blackburn, Lancashire, and is best known for his series of pictorial guides to the fells, though he wrote much else besides. He fell in love with the Lake District during a walking holiday in 1930 when he climbed Orrest Head near Windermere and was completely swept away by the views (how different history might have been if it had been pouring down that day).

He set about writing the books with the typical organisation of an accountant, planning from the start to have them all done in thirteen years, which he did. Many think they are written in a quirky font, but he actually hand-wrote them, screwing up and tossing away pages if he'd made a mistake. In addition to the books he was a founder member of Blackburn Rovers' supporters' club and a curator for many years at Kendal Museum, where you can still see exhibit labels handwritten by him.

He had a reputation for being grumpy but was perhaps just a man who preferred to keep himself to himself and eschew the spotlight. He sought solitude on the fells, though perversely his books were responsible for reducing the chances of that happening. It's hard to believe now but at one point the books were about to go out of print before they were saved and re-energised by the Wainwright Society and these days the fells are full of people keen to 'bag' all 214 Wainwright summits.

Wainwright died in 1991 and requested that his ashes be scattered at Innominate Tarn on the top of Haystacks, which overlooks Buttermere valley. St James, the small red church in Buttermere, has a window looking out onto Haystacks with a plaque to Wainwright beneath it. The church at St James doesn't have a graveyard because it's built on a big rock, meaning all the locals have to be transported to Loweswater or Lorton for burial.

Wainwright wasn't the first person to gain a reputation for hiking in this area; look closely on a map and you'll spot a footpath winding away from Honister Slate Mine called 'Moses Trod'. The Moses in question was an eighteenth-century gentleman by the name of Moses Rigg, quarry worker by day and distiller of illicit whisky by night. It's said that his still was stashed high up on Gable Crag and the route named after him is the one he took from the quarry to the still and down into Wasdale Head to sell his illicit hooch. Knowing that Wainwright had a bit of a rebellious streak, I feel sure he would have approved.

Selected Bibliography

For full bibliography please see www.cumbrianrambler.blogspot.co.uk

Books
Armstrong, Margaret, *Thirlmere Across the Bridges to Chapel 1849 – 1852* (Peel Wyke, 1989)
Bampton & District Local History Society, *A Cast Iron Community* (Bampton & District Local History Society, 2006)
Budworth, Joseph, *A Fortnight's Ramble to the Lakes* (Cadell & Davies, 1810)
Collingwood, W. G., *Lake District History* (Titus Wilson & Sons, 1928)
Darrall, Geoffrey, *Wythburn Church and the Valley of Thirlmere* (Piper Publications, 2006)
Day, Adam, *To Bid Them Farewell: A Foot & Mouth Diary* (Hayloft Publishing, 2004)
Hoyle, Norman & Sankey, Kenneth, *Thirlmere Water a Hundred Miles a Hundred Years* (Centwrite, 1994)
Hudson, John, *Sketches of Grange* (Original 1850, reprint, Landy Publishing, 2001)
Lysons Daniel, *Magna Britannia: Cumberland*, (Cadell and Davies, 1816)
Murray, John, *A Tour in the English Lakes with Thomas Gray and Joseph Farington* (Frances Lincoln, 2012)
Philipson, Douglas, *Lakeland Bobbin Makers* (Handstand, 2010)
Rough Fell Sheep Breeders' Association, *Kendal Rough Fell Sheep* (Stramongate Press, 2006)
Smith, Colin, *A Guide to Milestones, Mileposts and Tollbuildings of Cumbria* (Brow Bottom Enterprises, 2011)
Swallow, Bob, *Against the Grade* (Great Northern Books, 2011)
Tyler, Ian, *Thirlmere Mines and the Drowning of the Valley* (Smith Settle, 1999)
Whitehall, Penny, *Smardale Summers* (Heathdene Publications, 2014)
Woods, Jack, *The North Road* (J. Woods, 1996)
Wright, Joseph, *The English Dialect Dictionary V3* (Henry Frowde, 1905)

Websites
Archaeology UK http://www.archaeologyuk.org
British History Online http://www.british-history.ac.uk/
English Lakes www.English-lakes.com
Fell and Rock Climbing Club http://www.frcc.co.uk/
Herdwick Breeders Association www.Herdwick-sheep.com
Honister Slate Mine www.Honister.com
Northern Viaduct Trust http://www.nvt.org.uk/smardale.htm
St Bees Priory http://www.stbeespriory.org/
The Wainwright Society www.wainwright.org.uk/